WAR IS BEAUTIFUL

The *New York Times* Pictorial Guide to the Glamour of Armed Conflict*

* (in which the author explains why he no longer reads *The New York Times*)

WAR IS BEAUTIFUL

The *New York Times* Pictorial Guide to the Glamour of Armed Conflict*

David Shields

Afterword by
Dave Hickey

powerHouse Books

Brooklyn, New York

* (in which the author explains why he no longer reads *The New York Times*)

CONTENTS

Introduction 7

I. NATURE 13

II. PLAYGROUND 21

III. FATHER 29

IV. GOD 35

V. PIETÀ 41

VI. PAINTING 49

VII. MOVIE 61

VIII. BEAUTY 75

IX. LOVE 87

X. DEATH 95

Afterword 99

Citations 101

Photo Captions 102

Photography Credits 108

Acknowledgments 109

INTRODUCTION

FOR DECADES, upon opening *The New York Times* every morning and contemplating the front page, I was entranced by the war photographs. My attraction to the photographs evolved into a mixture of rapture, bafflement, and repulsion. Over time I realized that these photos glorified war through an unrelenting parade of beautiful images whose function is to sanctify the accompanying descriptions of battle, death, destruction, and displacement. I didn't completely trust my intuition, so over the last year I went back and reviewed *New York Times* front pages from the invasion of Afghanistan in 2001 until the present. When I gathered together hundreds and hundreds of images, I found my original take corroborated: the governing ethos was unmistakably one that glamorized war and the sacrifices made in the service of war.

The *Times*' photographic aesthetic derives, in part, from the paper's history. Patriarch and publisher Adolph Ochs bought the paper and transformed it into an institutional power. "All the news that's fit to print." "The paper of record." Although Ochs' mother and father, who were German-Jewish, had each come to the United States in the 1840s to escape anti-Semitism, Adolph remained nostalgic toward Germany and the continuity of European civilization. Faced with a different form of anti-Semitism in the States, Ochs and the subsequent publisher, his son-in-law Arthur Hays Sulzberger, made a conscious, self-protective decision to stave off any public perception that the *Times* was beholden to specifically Jewish interests.

In *The Trust*, Susan Tifft and Alex Jones explain the ramifications: "The *Times*'

reporting of Jewish persecution was remarkably thorough, and the paper often raised its voice forcefully in editorials, but crucial news stories were frequently buried inside the paper rather than highlighted on page one. . . . Like his late father-in-law [Adolph Ochs], he [Arthur Hays Sulzberger] did not want the *Times* to be viewed as a 'Jewish Paper,' but in his single-minded effort to achieve that end, he missed an opportunity to use the considerable power of the paper to focus a spotlight on one of the greatest crimes the world has ever known. The *Times* was hardly alone in downplaying news of the Final Solution. In the late 1930s and early 1940s, other major dailies . . . like the public at large, disbelieved reports of Jewish genocide in Europe or suspected that they were exaggerated in order to attract relief funds. But the *Times* was unique in one respect: as the preeminent newspaper in the country, with superior foreign reporting capabilities, it had much power to set the agenda for other journals, many of which took their cue from the *Times'* front page. Had the *Times* highlighted Nazi atrocities against Jews, or simply not buried certain stories, the nation might have awakened to the horror far sooner than it did."

Tifft and Jones' evocation—of a quasi-government entity positioning itself so as not to antagonize the Roosevelt administration's willful blindness to the situation of Jews in Europe—is predictive:

even when taking an editorial position against particular government actions, the *Times*, though considered "liberal," never strays far from a normative position. The center would never again not hold. The *Times* and the U.S. government use each other to instantiate their own authority. Throughout its history, the *Times* has produced exemplary war journalism, but it has done so by retaining a reciprocal relationship with the administration in power. The paper of record has become the paper of record by being so integrated with the highest levels of authority (James B. Reston simultaneously advising and editorializing in praise of JFK) that it knows precisely what truth the power wants told and then prints this truth as the first draft of history.

Iraqi photojournalist Farah Nosh, whose family was living in Baghdad, worked for the *Times* in Iraq and says that Iraqis knew there were no WMDs. She describes her reaction to encountering Judith Miller at the *Times* Baghdad bureau: "I remember seeing [Miller] coming in [to *The New York Times* Baghdad bureau] in her military uniform [fatigues]. I was confused: 'Who is she? Is she a reporter? Is she with the military?' Then realizing who she was and overhearing her talk about—I don't remember the details—how they were going to this location and her confidence that now that Saddam was out of power, they'd have all the access that they needed to find WMDs. I remember just

shaking my head like, 'Is this for real?' It never occurred to me the scale of her involvement."

Miller's—the *Times'*—intimate participation in the promotion of the war led directly to immeasurable Iraqi death and destruction. Nosh: "I think the toll is endless sadness. I don't know how to explain it, but my family, the family I know in Baghdad—are not the same family that I met when I first arrived [to photograph for the *Times*]. The family structure is the most important thing in our culture and when that's disrupted, nothing is the same. The family structure has been hugely disrupted in Iraq. The degree of posttraumatic stress is something that we'll never even begin to comprehend."

After U.S. troops left Iraq, former *Times* Baghdad bureau chief John F. Burns wrote in a *Times* war blog: "America, for all its mistakes—including, as so many believe, the decision to invade in the first place—will at least have the comfort of knowing that it did pretty much all it could do, within the limits of popular acceptance in blood and treasure, to open the way for a better Iraqi future." President Lyndon Johnson said about Vietnam, "I can't fight this war without the support of *The New York Times*." A *Times* war photograph is worth a thousand mirrors.

War photojournalist Ashley Gilbertson, who also worked for the *Times*, says that

photographers found it difficult to work in Iraq because the topography doesn't show up well in pictures; the country's natural light is terrible for shooting: "Iraq was just a flat, ugly, Middle Eastern country with a shitload of oil." Yet the *Times*' front-page war photos, while of necessity containing harsh details, consistently yield an Iraq (and Middle East) of epic grandeur. The program of the photos is the same as that of the *Iliad*: the preservation of power.

Reviewing nearly a thousand front-page war pictures, I noticed that many, even most, repeat certain visual tropes, or gestures. This book aims to demonstrate what these patterns are and how these patterns work together.

War Is Beautiful, chapter by chapter:

Nature. Military action becomes a habitat, the preserve of masculine desire for war. Men are as glorious as nature when in bellicose tribes occupying wilderness and believing in regeneration through violence.

Playground. War is the playground that authorizes the male psyche to exercise its passions. It's also the dangerous arena into which the *Times* sends its employees to win awards and promote its brand.

Father. Within another culture, the American warrior is presented as protection and relief from the chaos and blood that he himself has unleashed upon the indigenous culture. Children need faux-fathers because their real fathers may already be dead.

God. The military commands the globe; the *Times* surveys and imagines the battlefield from a vantage point high above the field of play; everything is under control for the creation of a new world.

Pietà. War death = Christ's death on the cross. The process of removing the body from the cross and battlefield is sacred. Mourning is always muted and respectful. Hysterical grief is banned.

Painting. War stuns the senses to the point that its portrait needs to be painted over and over. These images apotheosize adrenaline and firepower, preserving American idols.

Movie. The positing of action heroes, video games, and special effects in cinematic stills. Countless American war movies are behind the image screens. Technology and art erase the body's grotesque disfigurement and death.

Beauty. Portraits of the other: the occupied and displaced, mostly women and children, beauties seeking salvation. Male sacrifice is consecrated in these faces—the rationale for going to war. Fathers and God are the necessary destroyers.

Love. Proximity to death, which marks the separation between military and civilian life, is unmistakably erotic. Like sex, war is a force that gives us meaning; a male soldier's combat death is as close as he's ever going to get to birth, to the origin of things.

Death. The machine rolls on; the war dead incarnate the immortal epic, told as if they agreed to lie supine to support the light and civilization that surely surround them.

Art is an ordering of nature and artifact. The *Times* uses its front-page war photographs to convey that a chaotic world is ultimately under control, encased within amber. In so doing, the paper of record promotes its institutional power as protector/curator of death-dealing democracy. Who is culpable? We all are; our collective psyche and memory are inscribed in these photographs. Behind these sublime, destructive, illuminated images are hundreds of thousands of unobserved, anonymous war deaths; this book is witness to a graveyard of horrendous beauty.

David Shields
Seattle
June 2015

When danger or pain press too nearly, they are incapable of giving any delight, and are simply terrible; but at certain distances and with certain modifications, they may be, and they are delightful, as we every day experience. The cause of this I shall endeavour to investigate further.

—Edmund Burke

I. NATURE

American hero-figures and metaphors for the American experience were not so much derived from postulates about nature as they were from extended experience in the wilderness. . . . The mediating figure of the frontier hero was not only a psychological but a social and political necessity. White Americans required such a figure in order to deal successfully with the Indians in battle, trade, and diplomacy and to live successfully in the wilderness. They also required a moral rationale for claiming and conquering Indian lands; otherwise, they would simply be exercising, like the Indians, the right of the mighty over the weak. . . . Yet [the frontier hero's] means of relating to Indians and wilderness are the means of violence and murder; he achieves kingship over his preferred world and people by destroying them in battle. Like the hunter-heroes of Indian mythology, who kill and devour the mystic deer that embodies the spirit of their earth mother, his creative act of love, of self- and societal regeneration, is an act of violence.

—Richard Slotkin

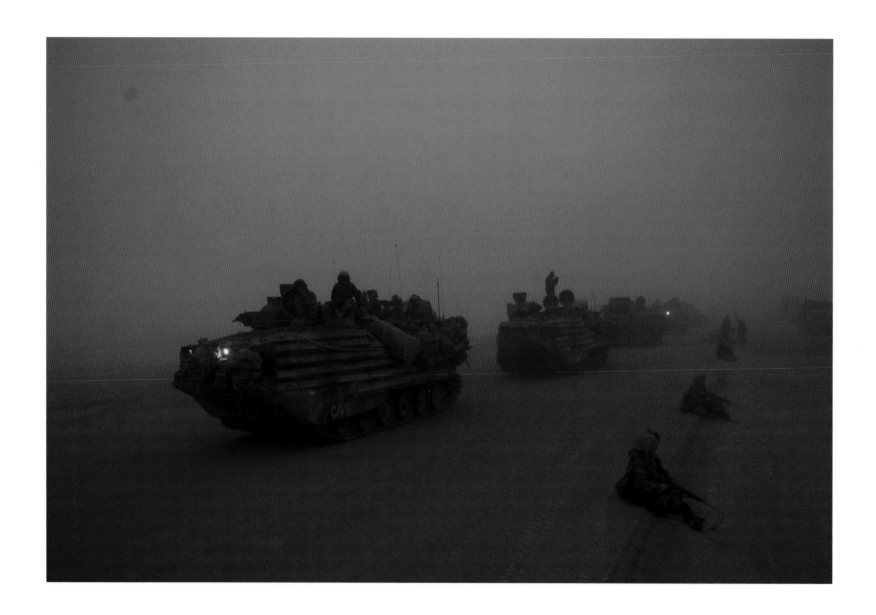

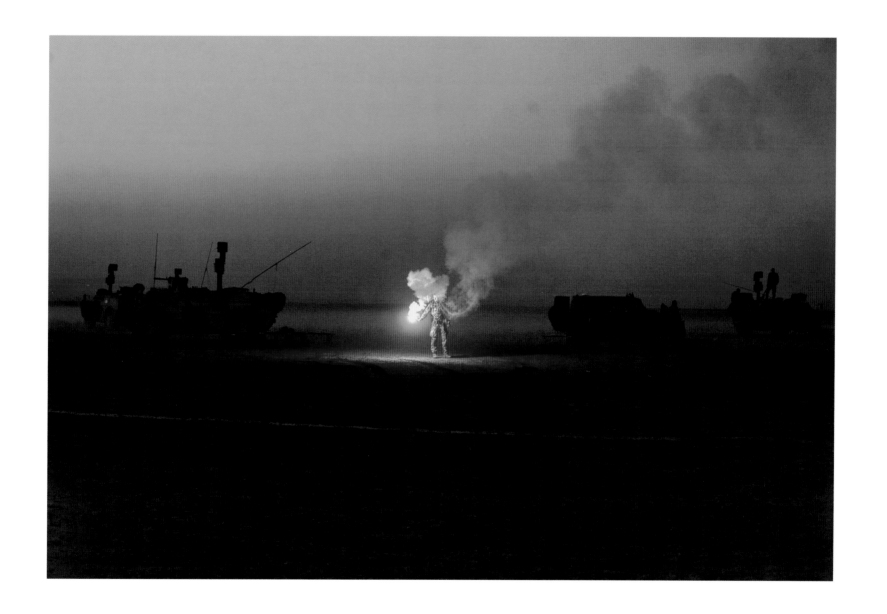

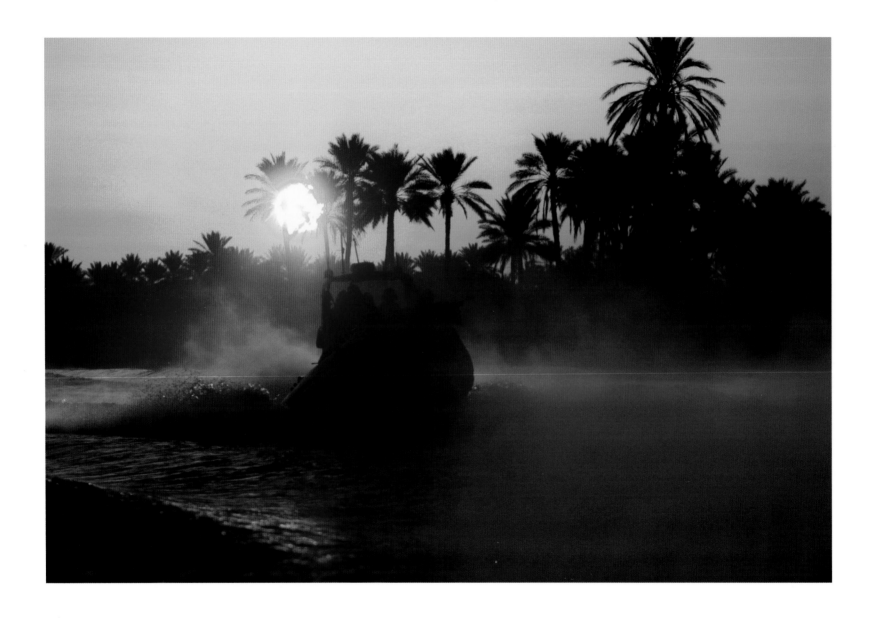

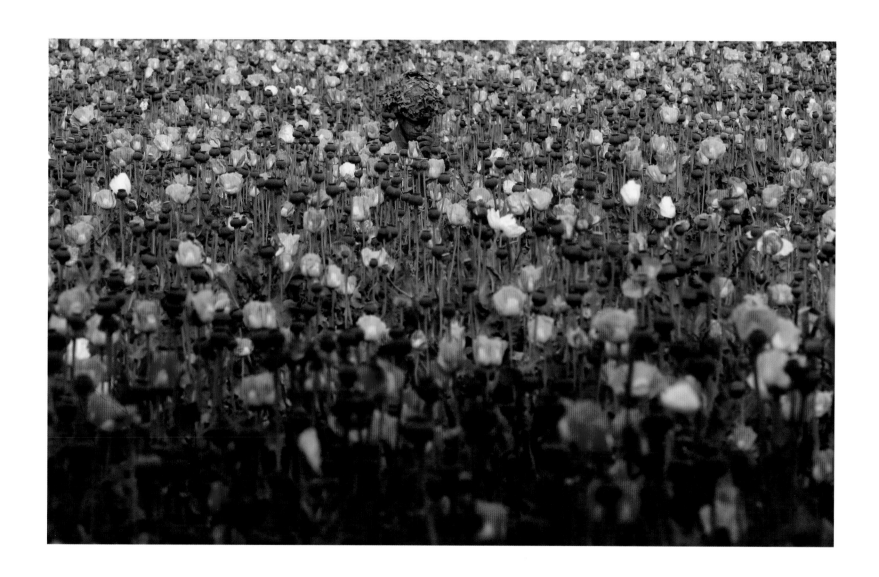

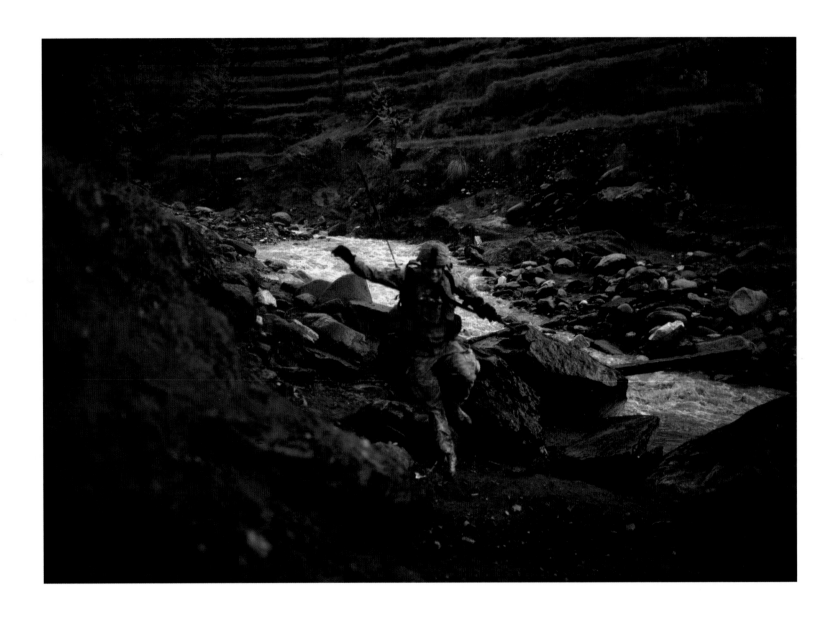

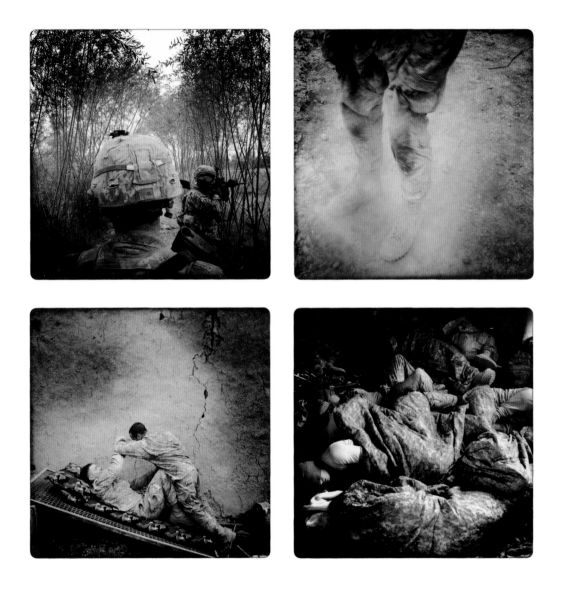

II. PLAYGROUND

Combat is the poor man's cocaine.

—John Hoagland

The real reason why women have so seldom participated in war on any scale is less their own disabilities than the psychological handicaps of men. Biologically speaking, women are superior to men in several ways, of which the most important one is the ability to have children. Well realizing their own dispensability, men seek to compensate; indeed, it would scarcely be too much to say that much of human "society" always has been and still is organized specifically in order to provide them with that compensation. . . . Depending on one's point of view, some of these forms deserve being called ridiculous, others serious, and others still—involving as they do self-sacrifice—sublime. Yet there is no denying that, of all human activities, war is in some ways the most suitable one for the purpose.

—Martin van Creveld

His spirit is exhausted at the peak of its achievement. His meridian is at once his darkening and the evening of his day. He loves games? Let him play for stakes. This you see here, these ruins wondered at by tribes of savages, do you not think that this will be again? Aye. And again. With other people, with other sons.

—Cormac McCarthy

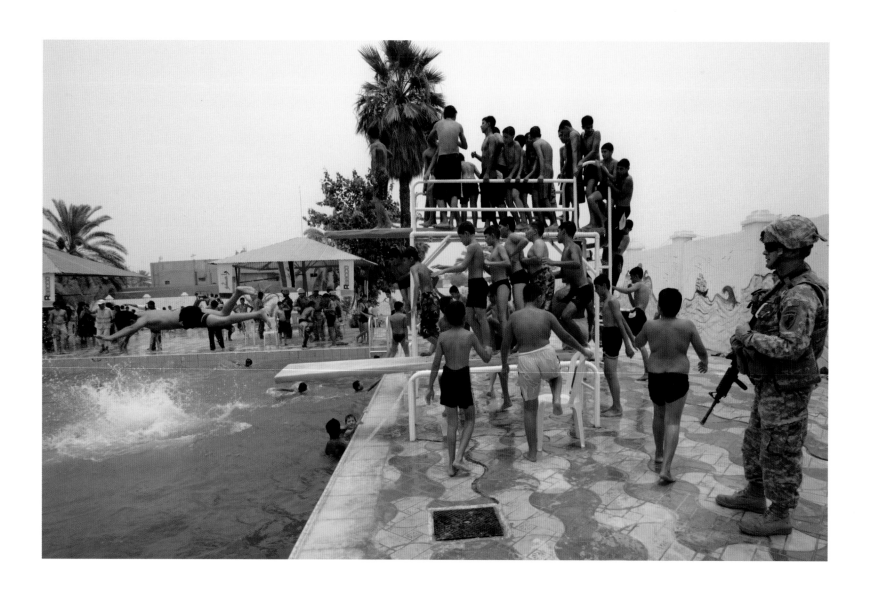

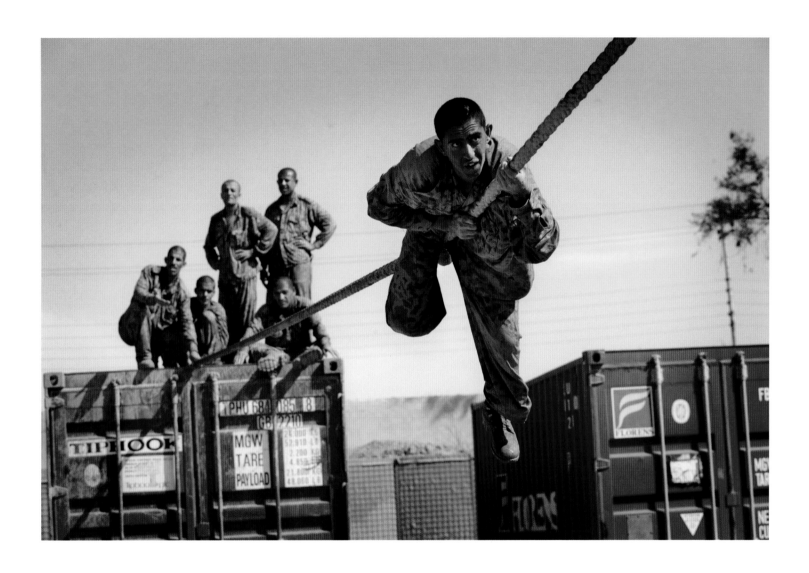

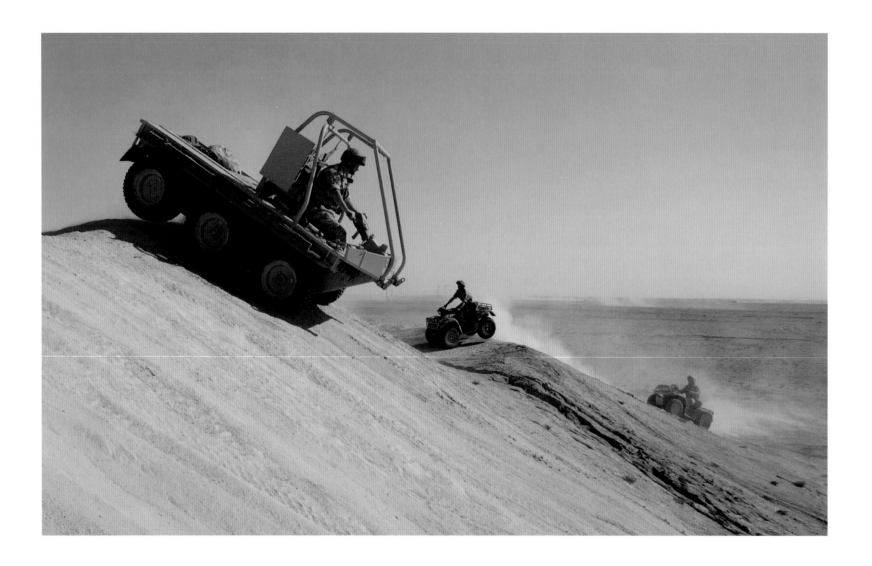

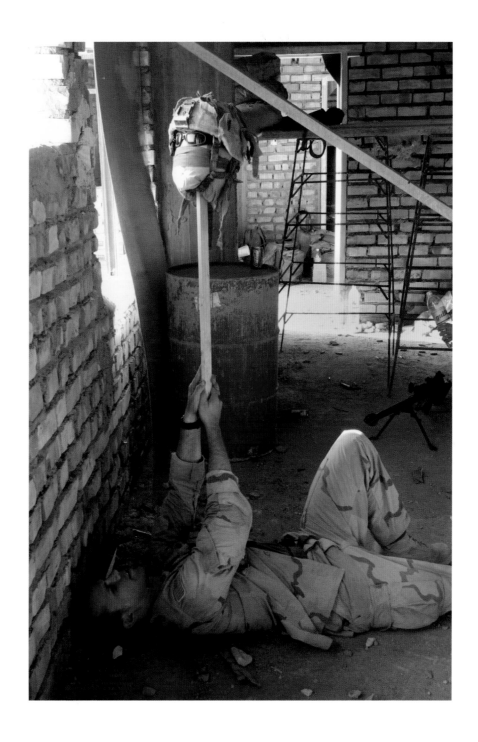

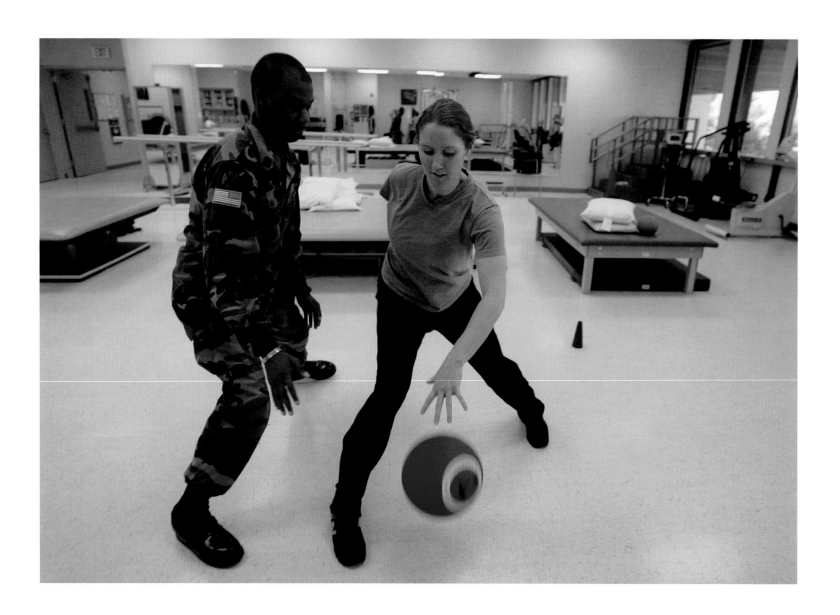

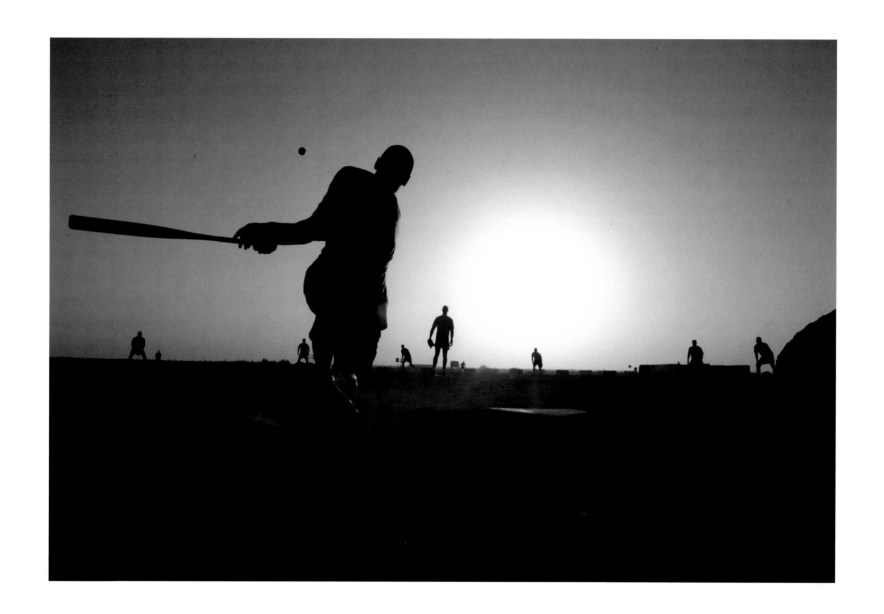

III. FATHER

I have to say, in terms of [*The New York Times* Baghdad bureau's] relationship to the Iraqi staff, that part was most concerning to me. It had a colonial feel to it—just a division in how the Iraqi staff was treated. I'd go to other bureaus and the Iraqi staff would be sitting with the reporters and allowed to drink the same tea and coffee. For some reason there was an unsettling, somewhat colonial relationship of the Iraqi staff to the American staff [of the *Times*]. They were Iraqis in their own homeland, being treated like they were the visitors. I think that was exemplified in the war itself. The occupation. . .I think that was experienced at the *Times* bureau as it was on the streets with the [U.S.] military.

—Farah Nosh

BRIAN LAMB: Last question. Of all the assignments you've had, which one was the most exhilarating?
JOHN F. BURNS [former *New York Times* Baghdad bureau chief]: Exhilarating? I think the wars. I think the wars because—
LAMB: . . .these wars right now?
BURNS: These wars because they pose the essential questions—essential questions of life in its darkest form because they bore so heavily on the interest of the United States and of my newspaper, an American newspaper.

—*Q&A*, C-SPAN, November 17, 2010

Now this son whose father's existence in this world is historical and speculative even before the son has entered it is in a bad way. All his life he carries before him the idol of a perfection to which he can never attain. . . . For it is the death of the father to which the son is entitled and to which he is heir, more so than his goods. . . . The world which he inherits bears him false witness. He is broken before a frozen god and he will never find his way.

—Cormac McCarthy

[*Times* owner and publisher during World War I] Adolph [Ochs], who was distantly related to the German poet Heinrich Heine, had a sentimental attachment to the land of his forebears. In his usual innocent way, he had refused to believe that Germans could ever be seduced by Hitler's corrupting charisma.

—Susan E. Tifft and Alex S. Jones

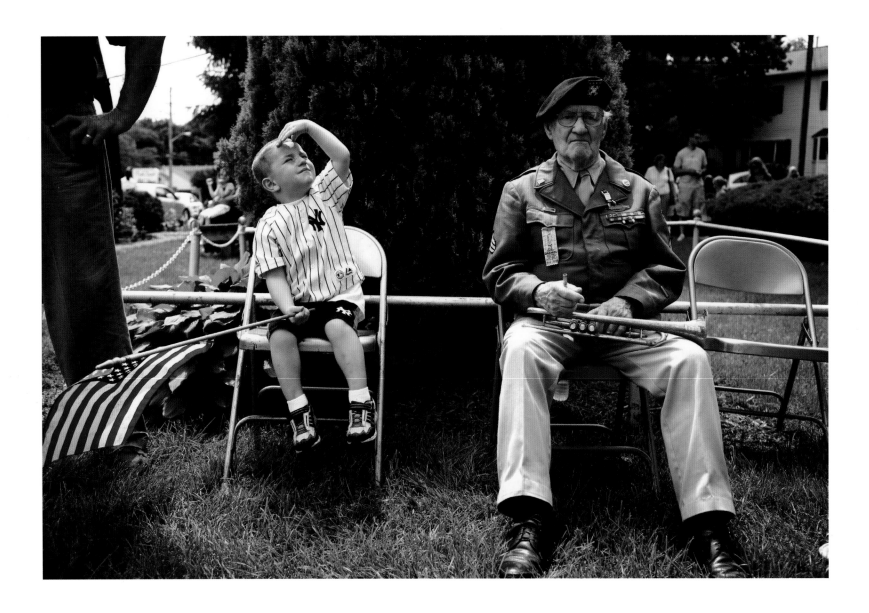

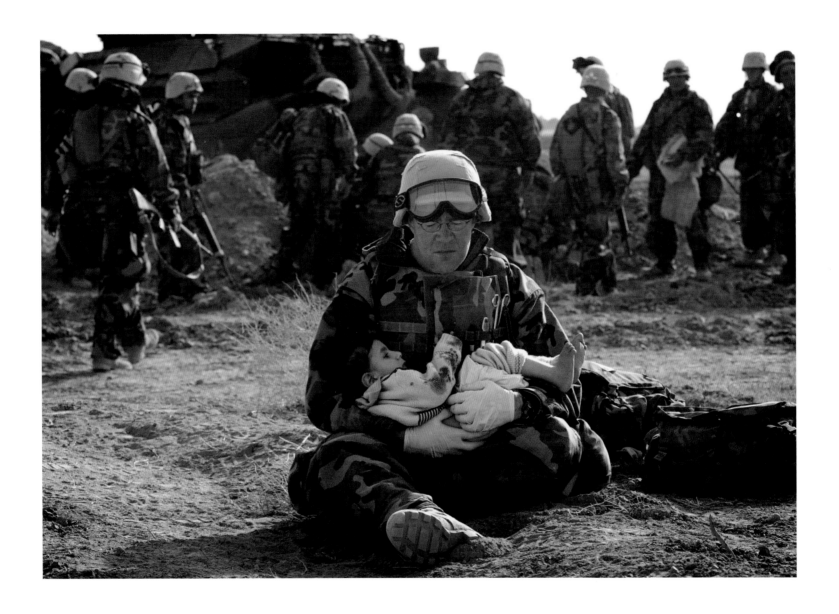

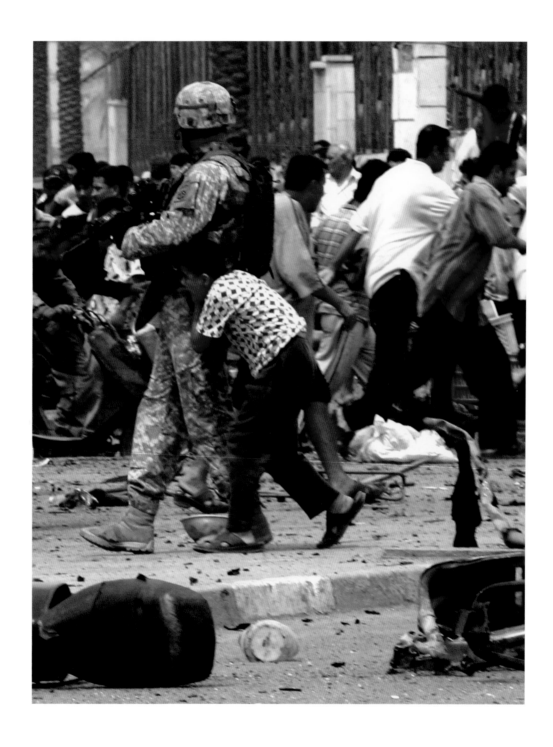

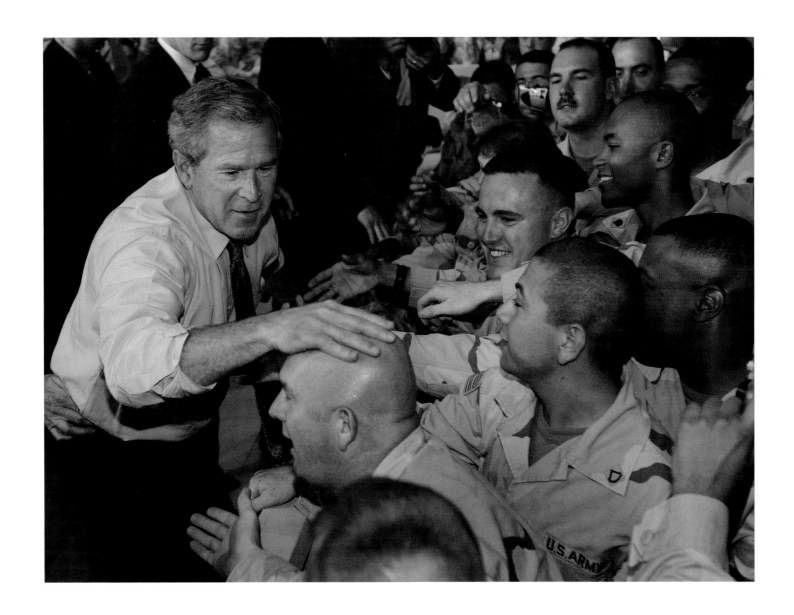

IV. GOD

The people who write in [the pages of the *New York Times*] seem to have a need to believe
that their government, while sometimes somewhat wrong, of course, can't be *entirely* wrong,
and must at least be trusted to raise the right questions. These writers just can't bear the
thought of being completely alienated from the center of their society, their own government.
. . .Nudity seems to imply that anything can happen, but The *New York Times* is committed
to telling its readers that many things will *not* happen, because the world is under control,
benevolent people are looking out for us, the situation is not as bad as we tend to think, and
while problems do exist, they can be solved by wise rulers.

—Wallace Shawn

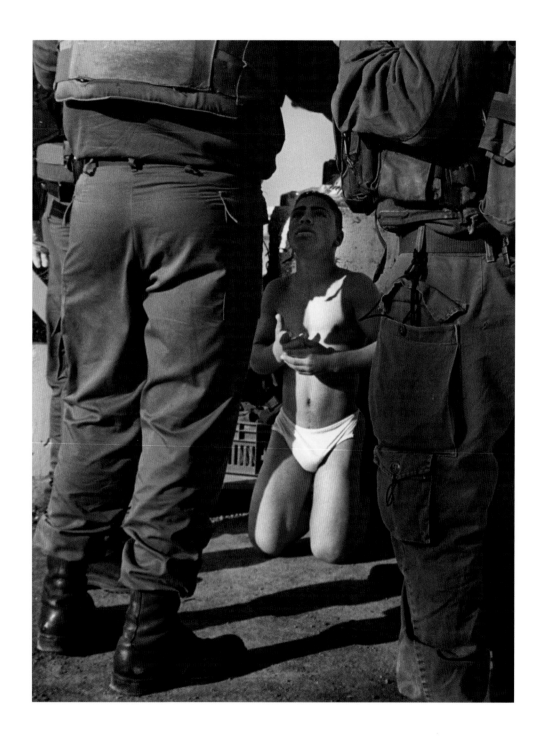

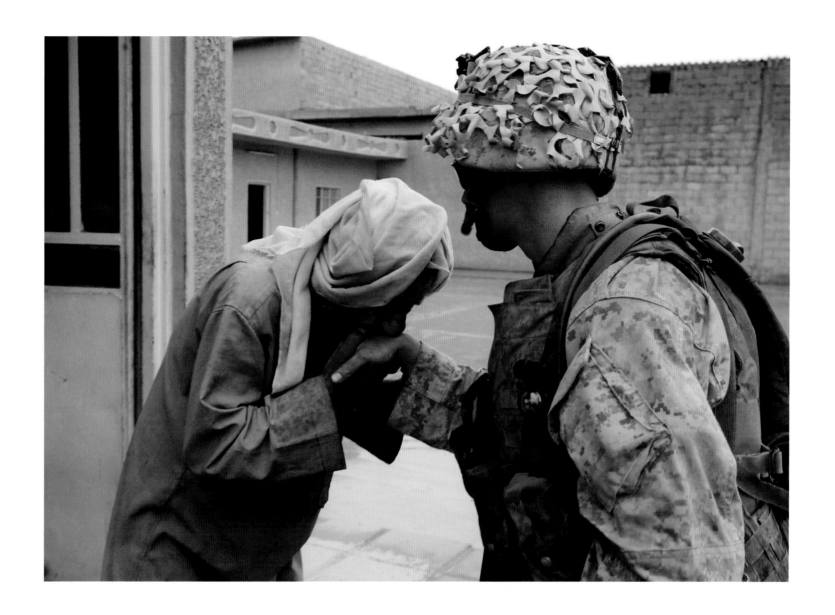

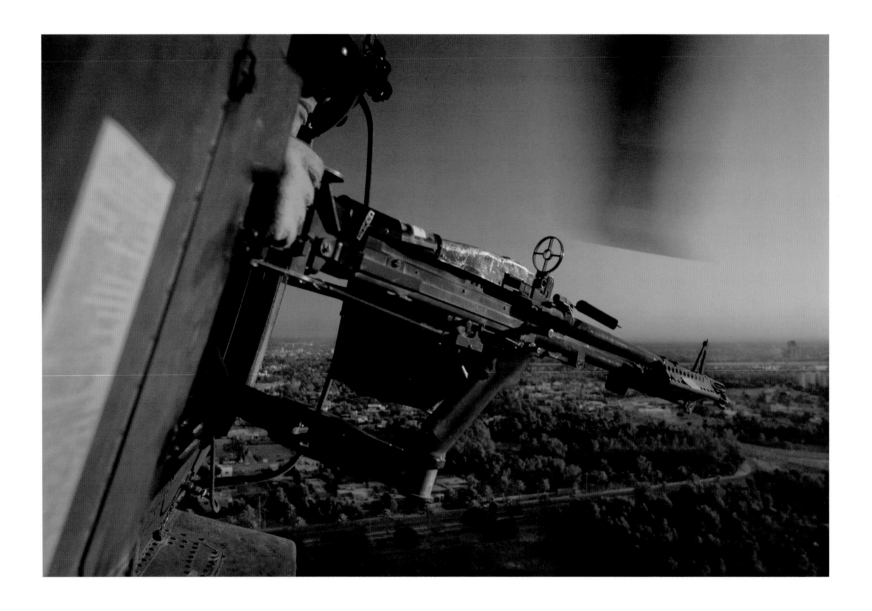

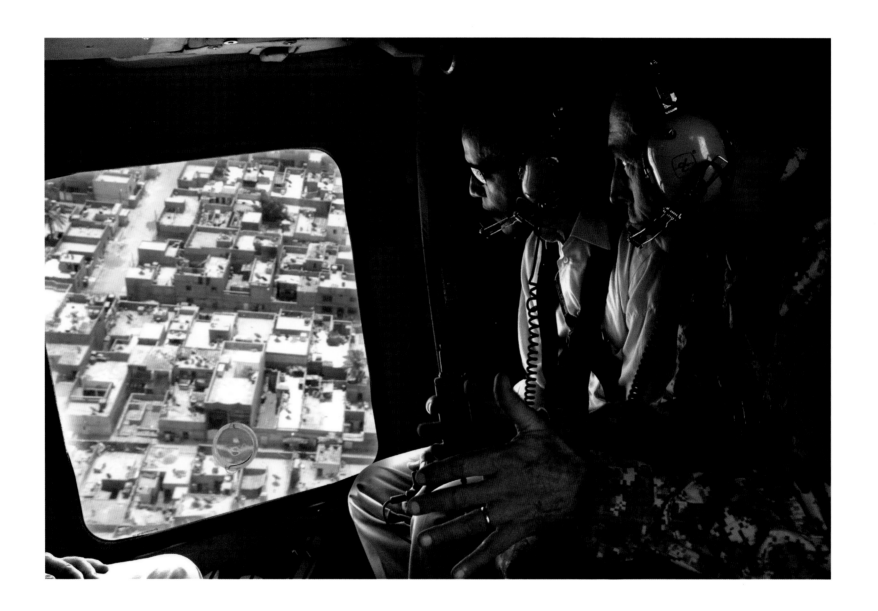

V. PIETÀ

No matter what we say, the end of all sadness is a swoon into divinity.

—E. M. Cioran

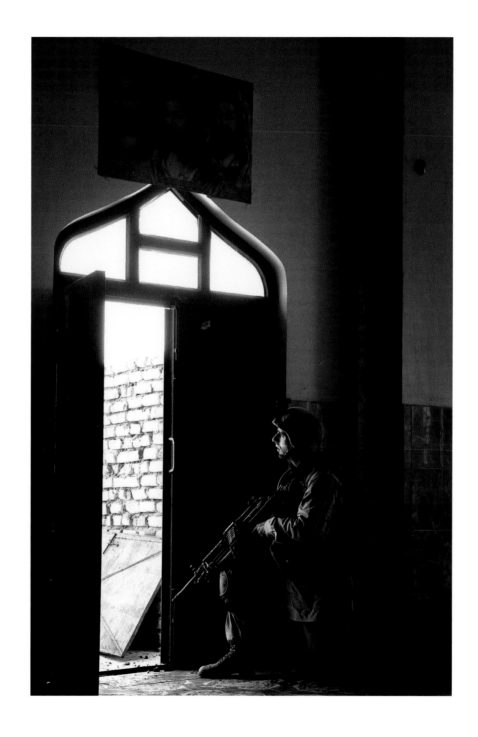

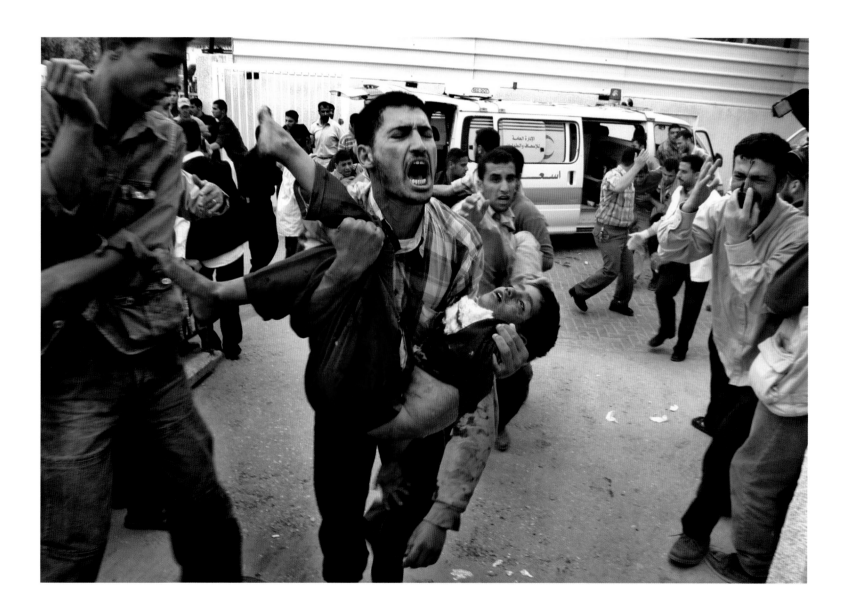

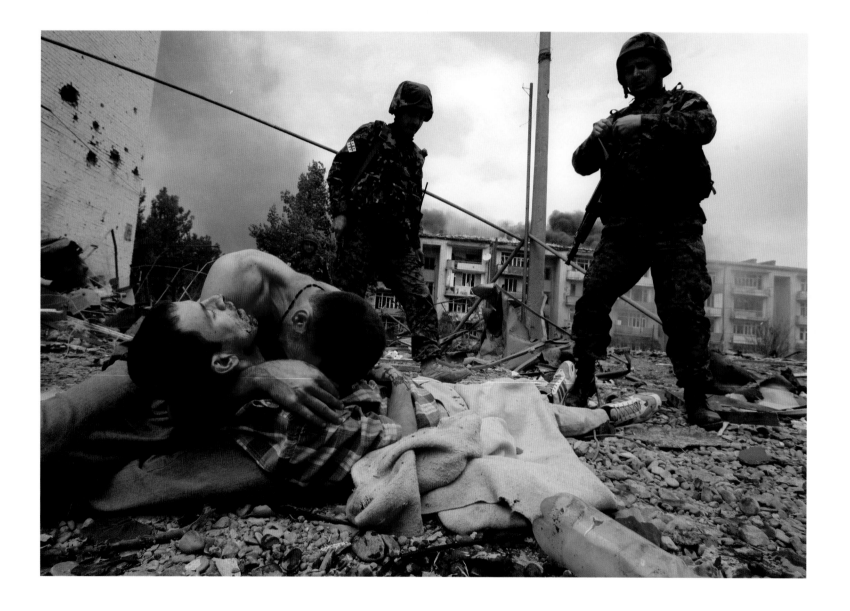

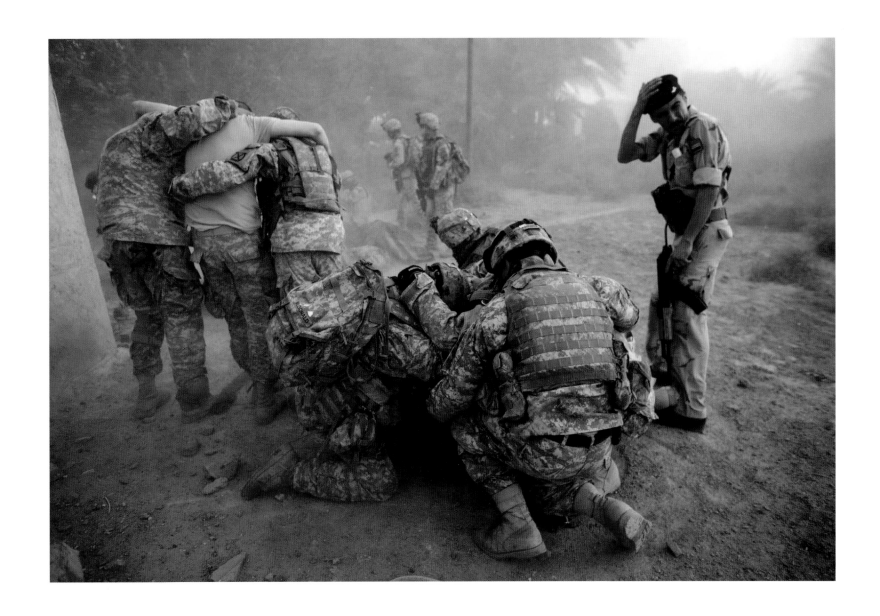

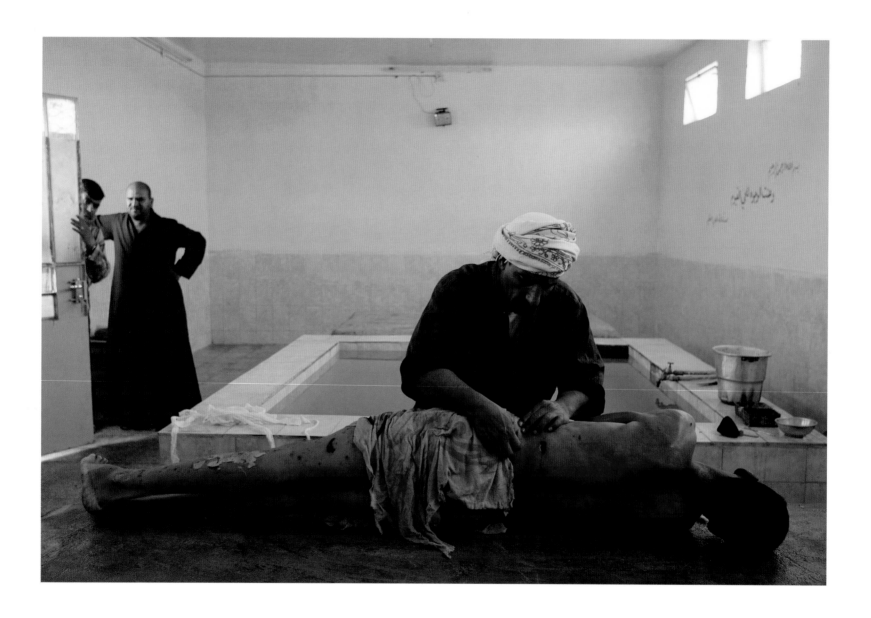

VI. PAINTING

[B]ecause from the moment photography came into existence, it has precluded almost everything. . . . When those things are painted, we find ourselves de facto in the false. So they have to be "pushed" to the point where they gain a beautiful appearance, to the point where we want to look at them.

—Gerhard Richter

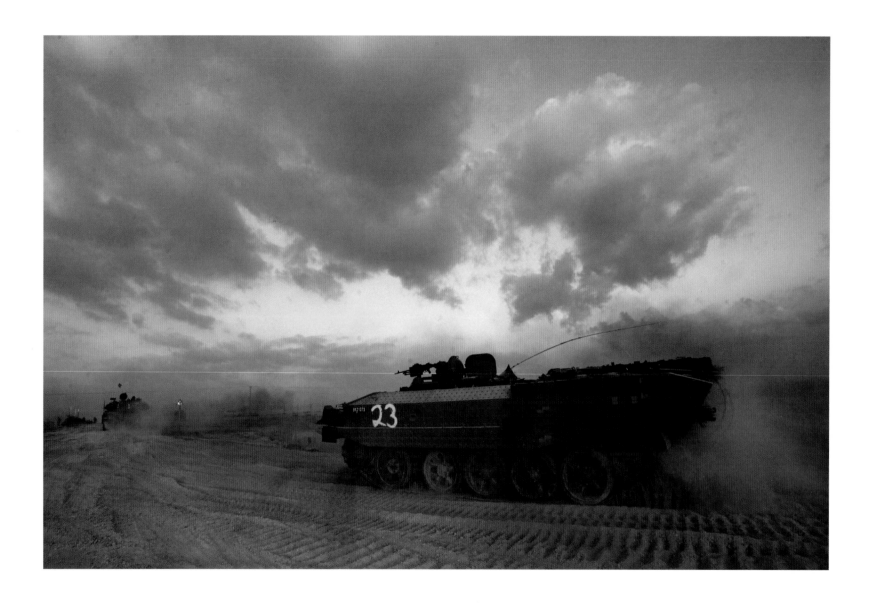

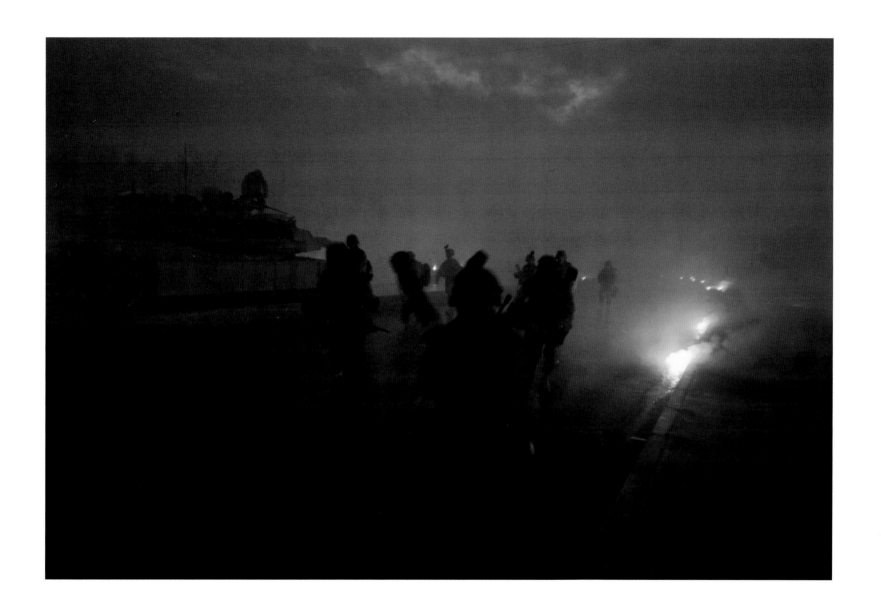

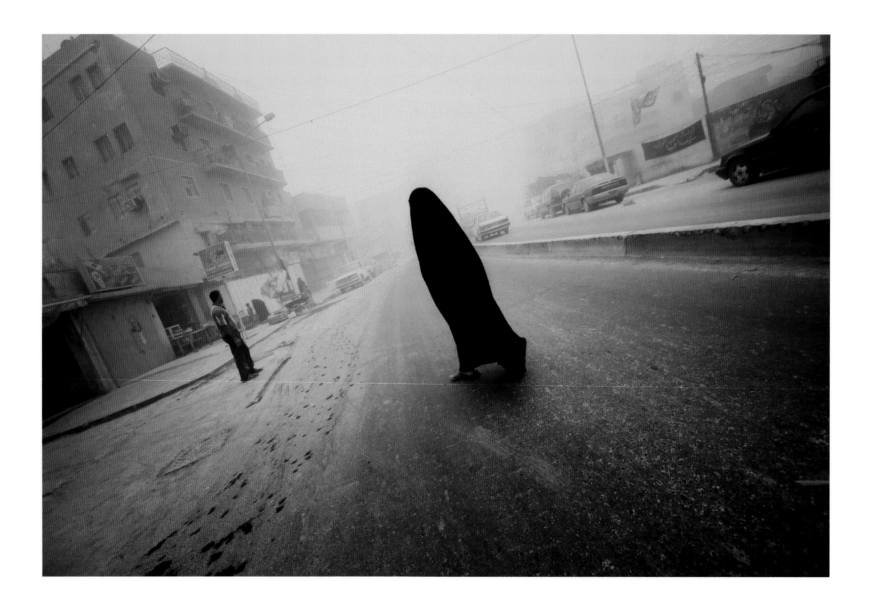

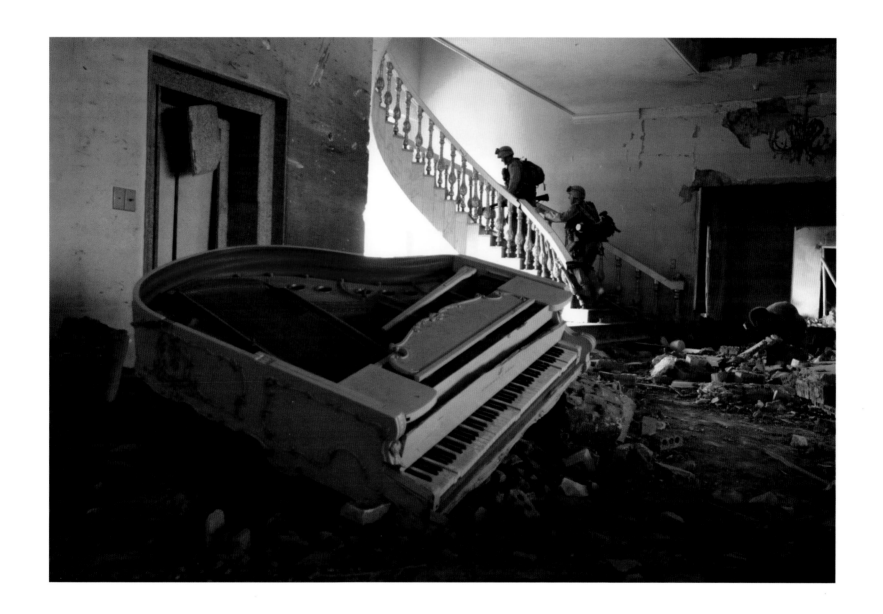

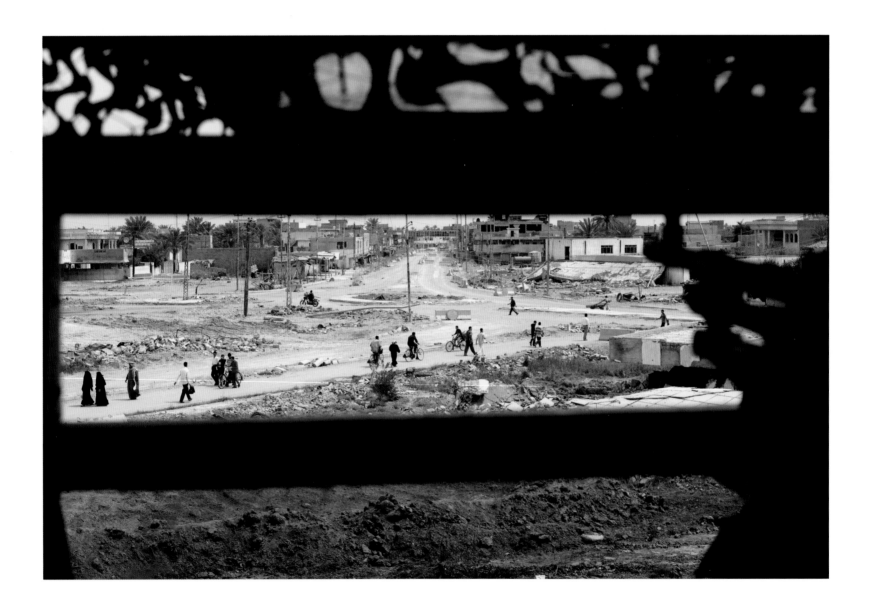

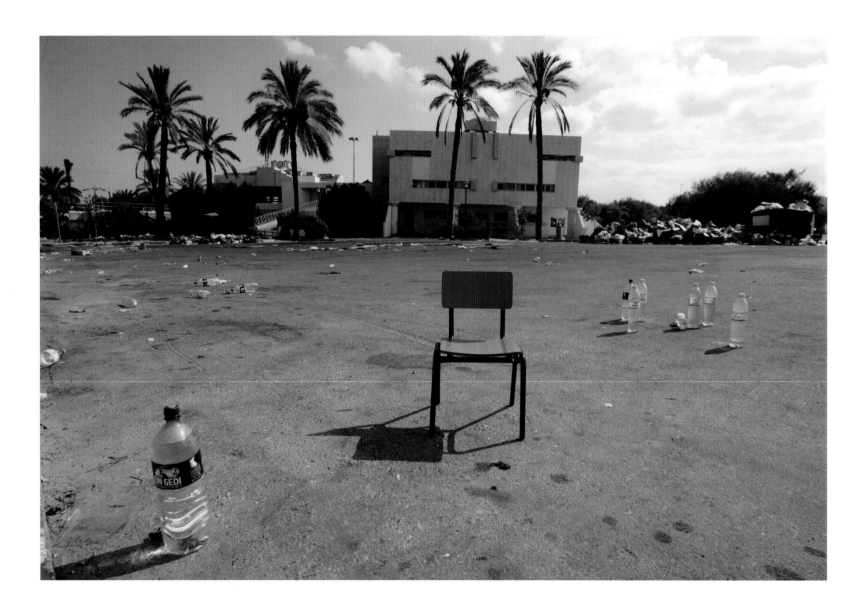

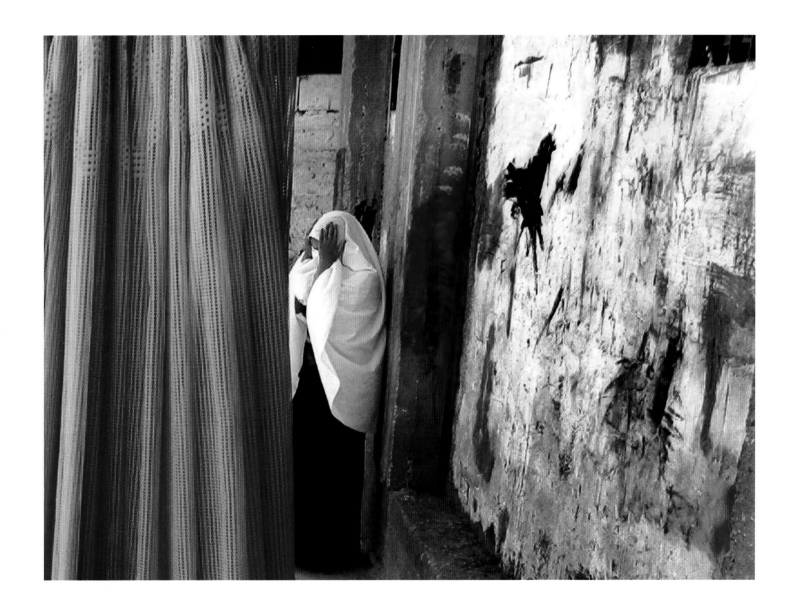

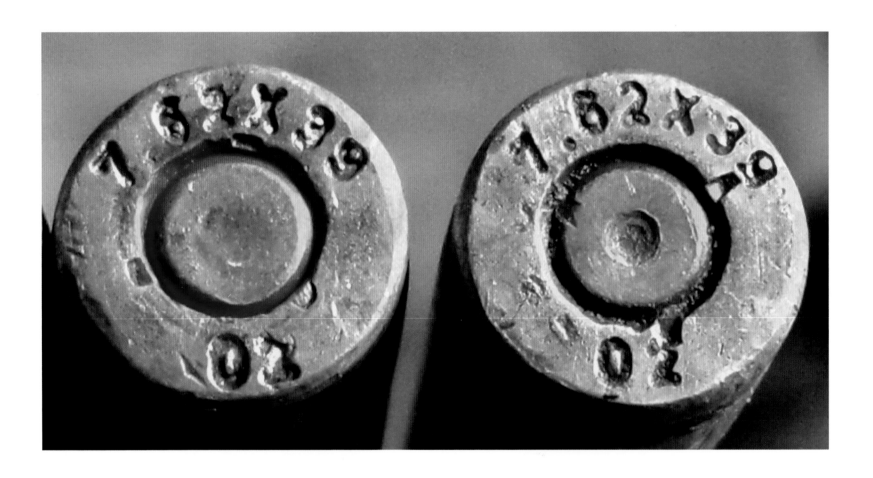

58

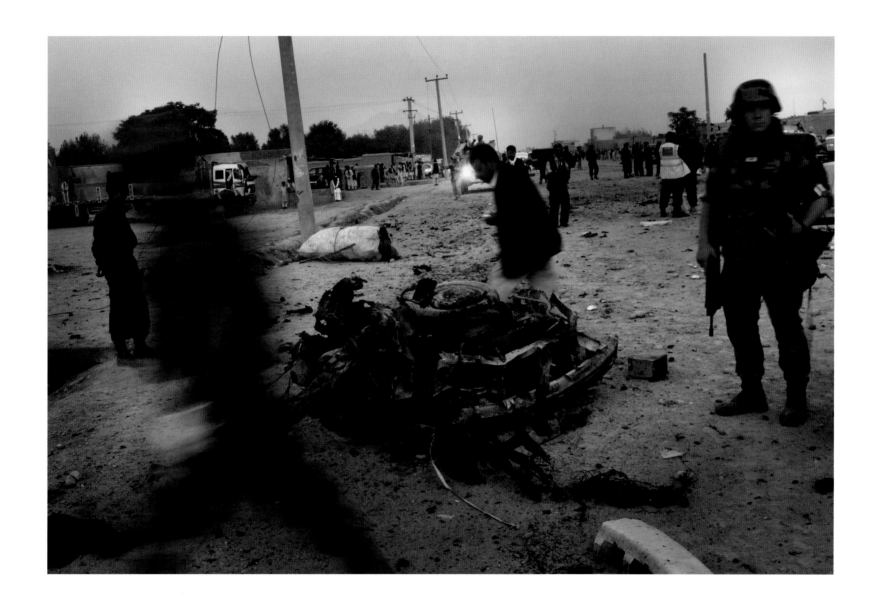

VII. MOVIE

Then came a faint sound of music, and the marine found a tune [on a battery-operated portable radio]: that sappy theme song from the movie *Titanic*. A marine in the corner of the mosque started singing along, and then another on the other side of the mosque. Soon a choir formed from among the toughest men in the American military, singing along to Celine Dion from a destroyed mosque in downtown Falluja.

—Ashley Gilbertson

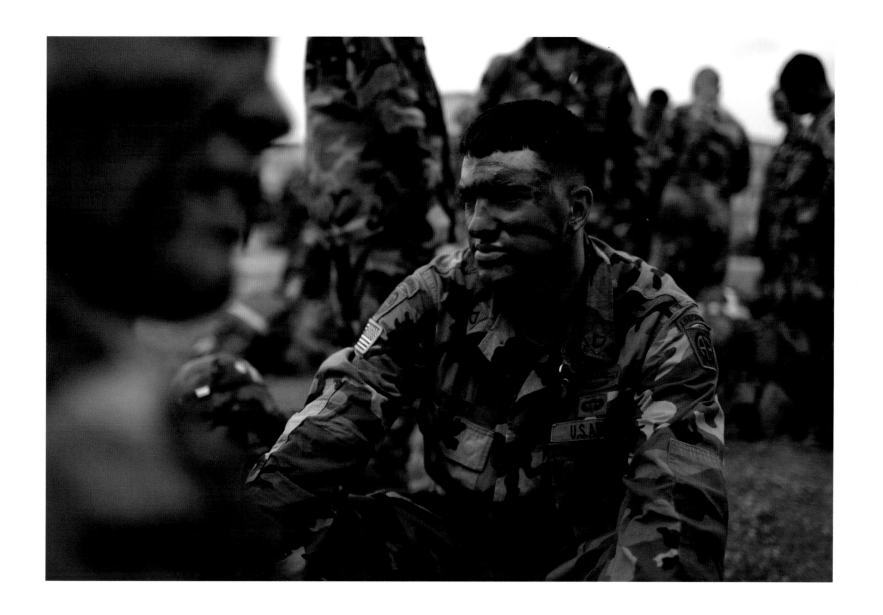

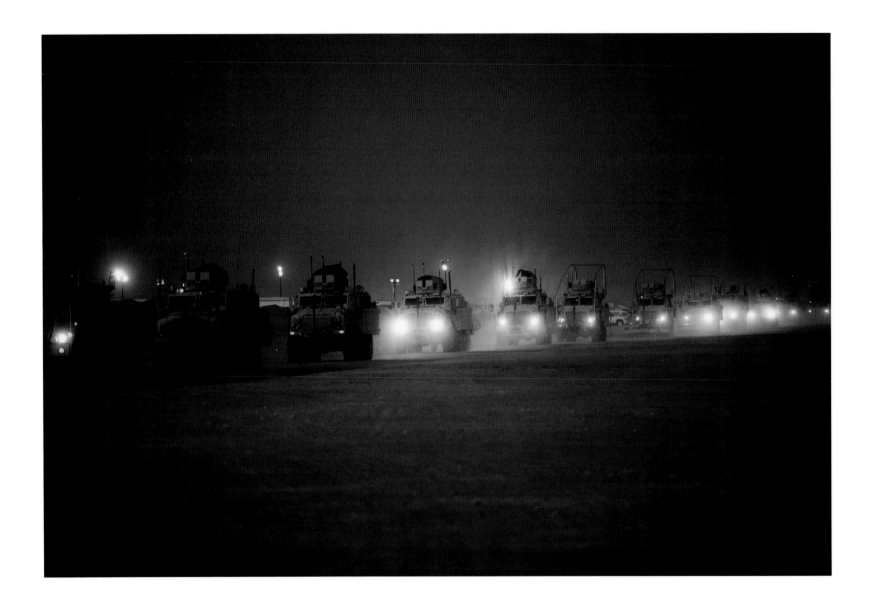

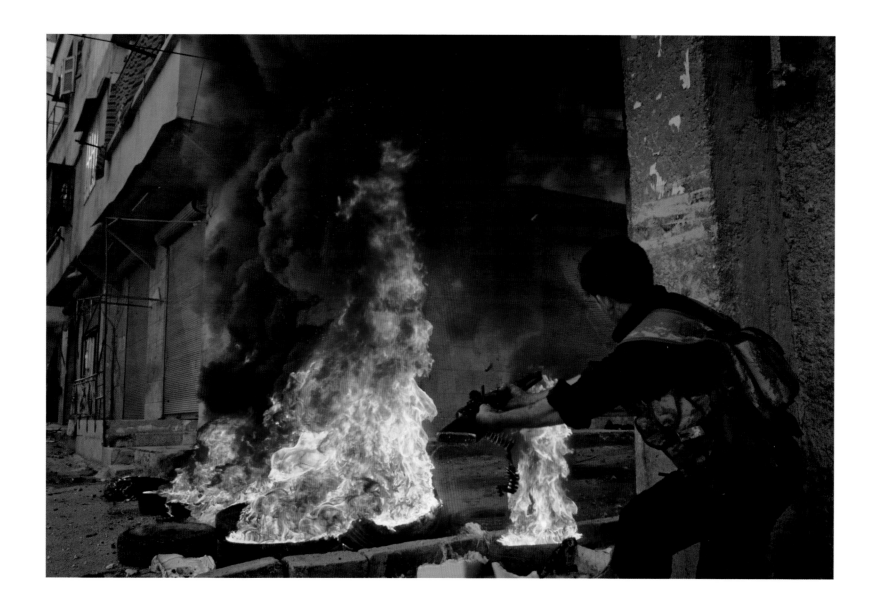

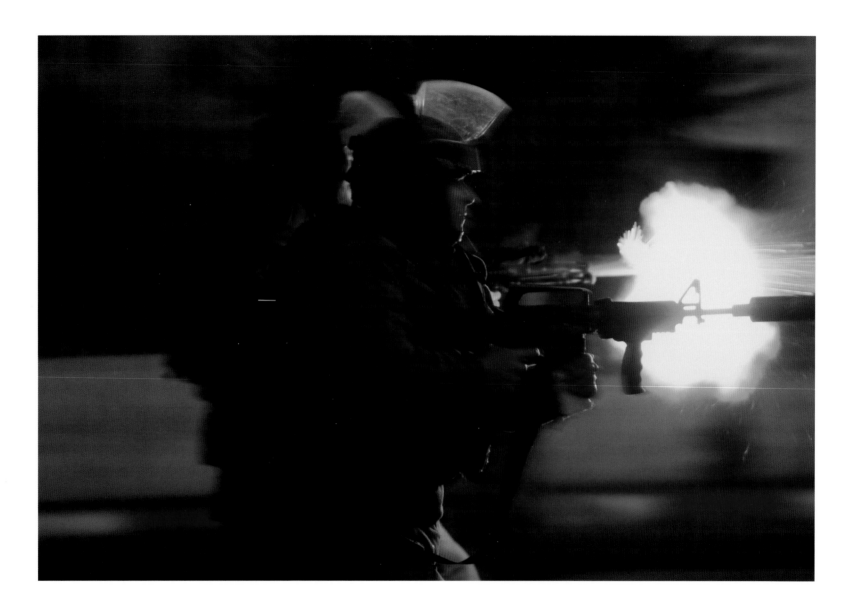

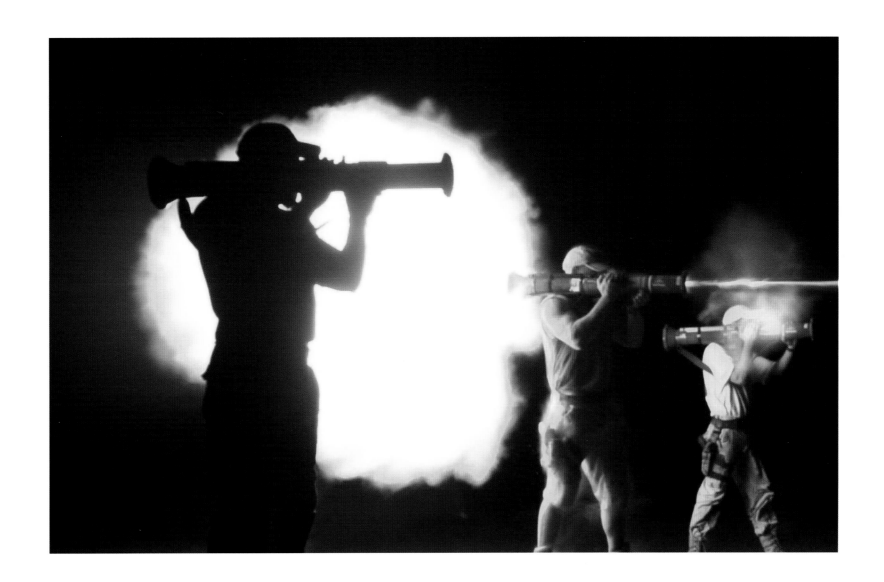

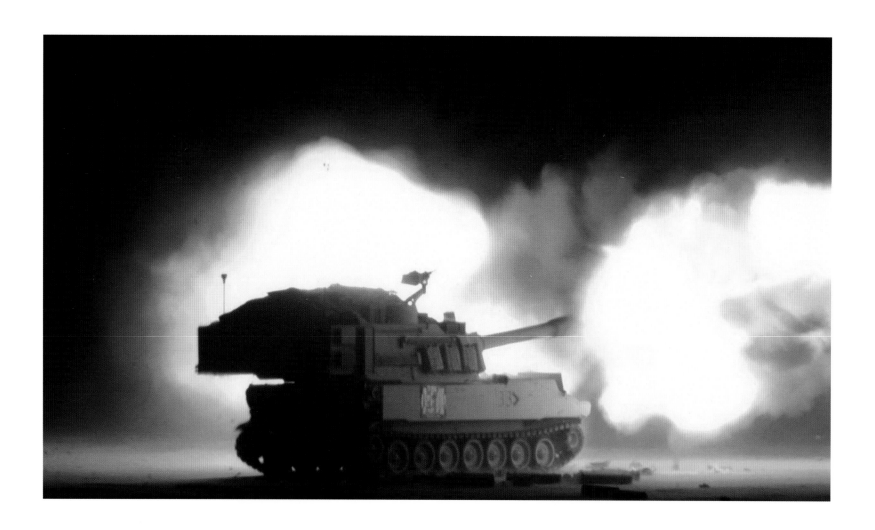

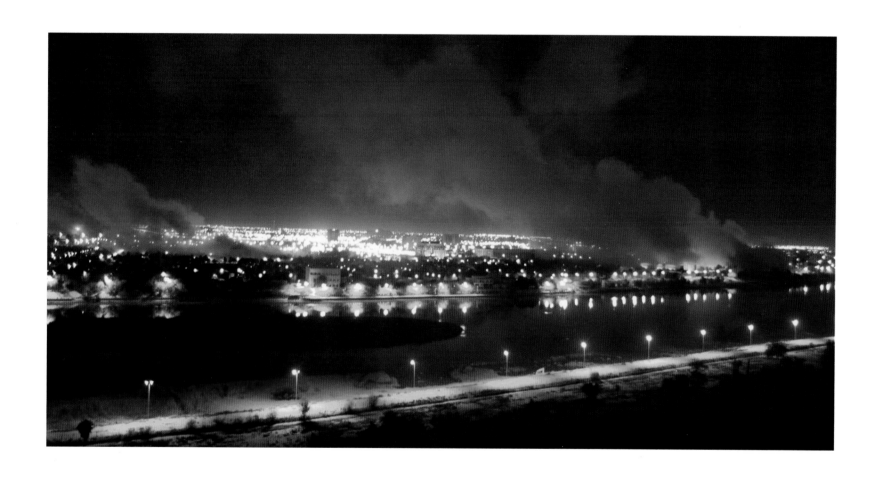

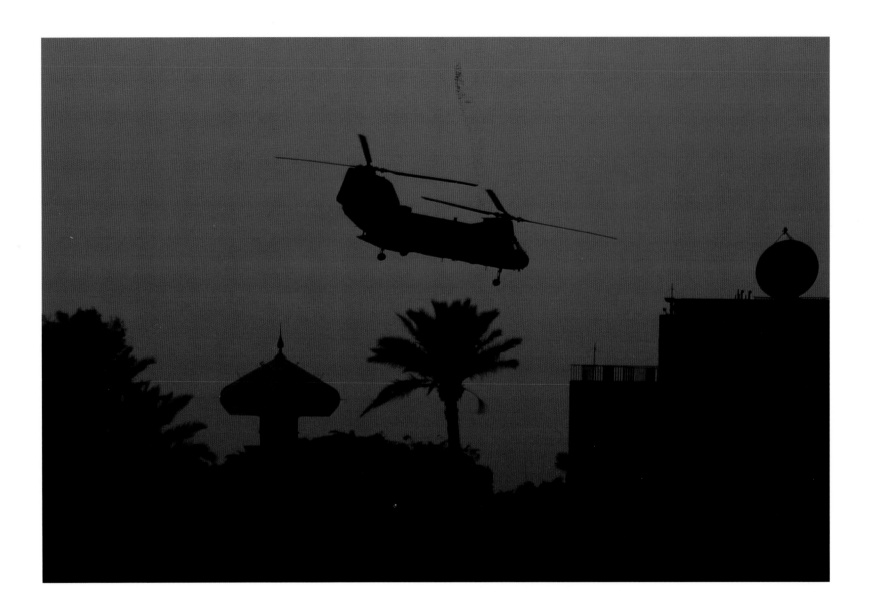

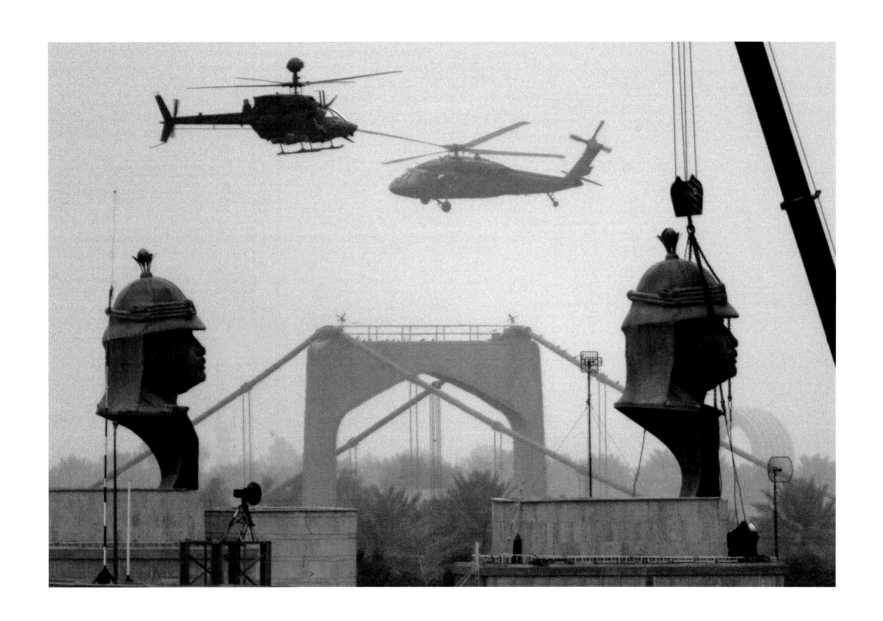

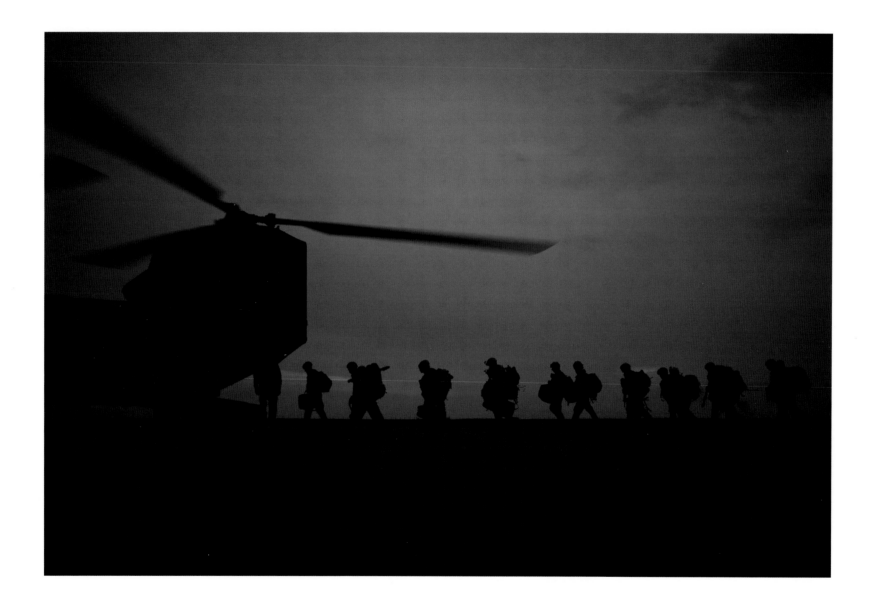

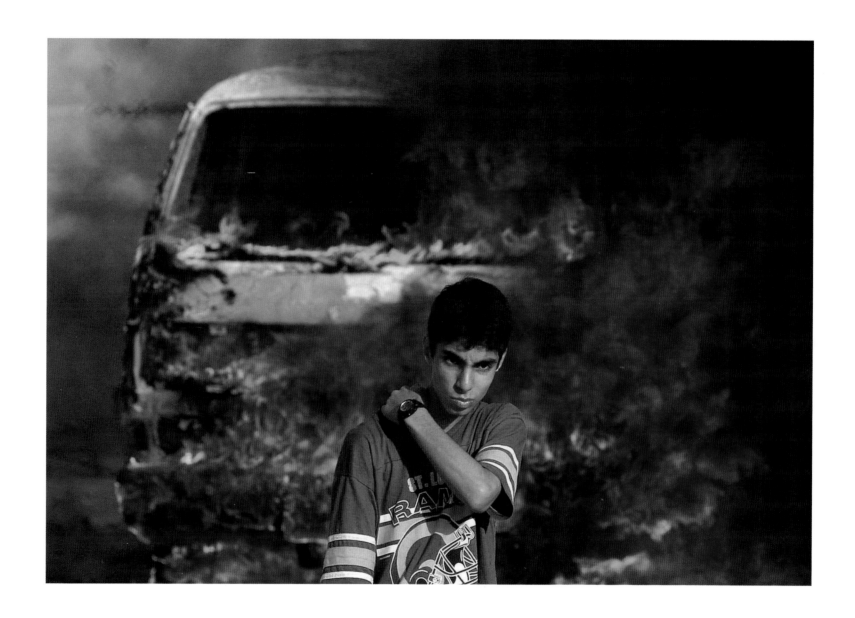

VIII. BEAUTY

For all the variegated multiplicity of its forms, the practice of sacrifice can be reduced to just two gestures: expulsion (purification) and assimilation (communion). These two gestures have only one element in common: destruction.

—Roberto Calasso

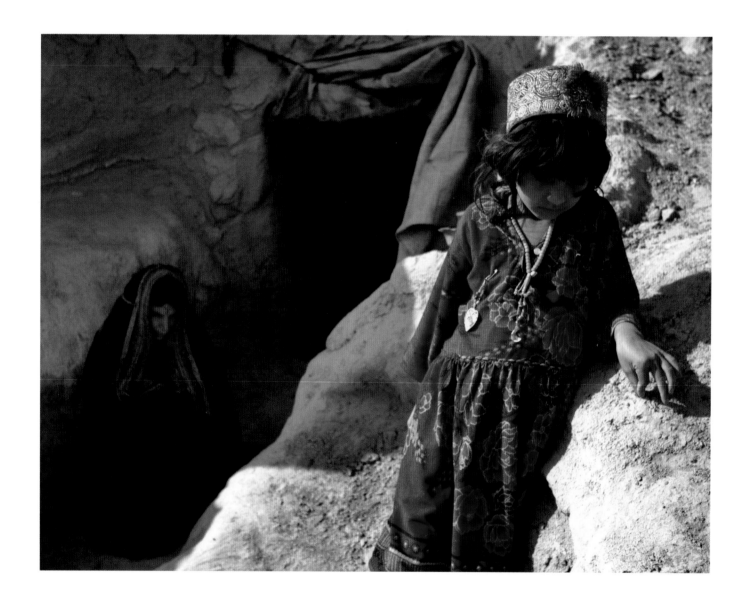

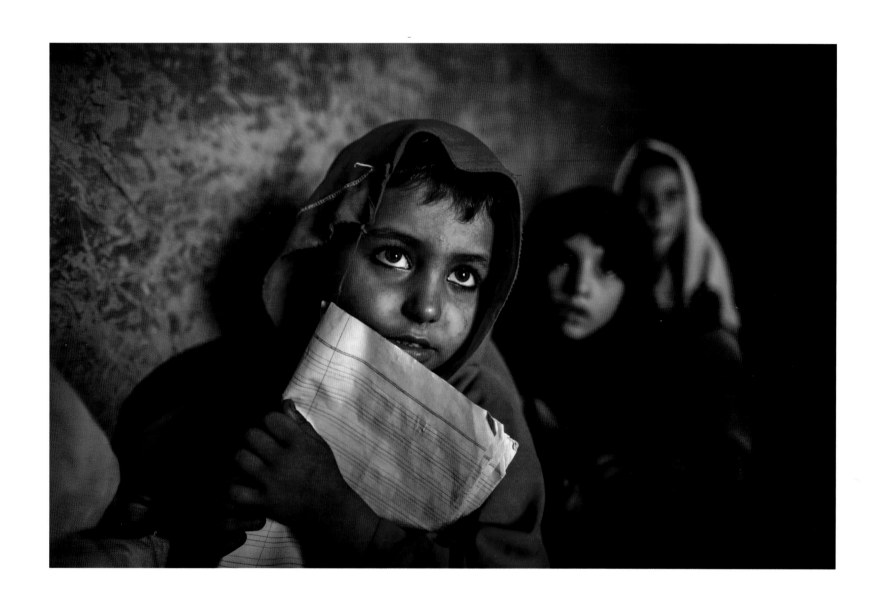

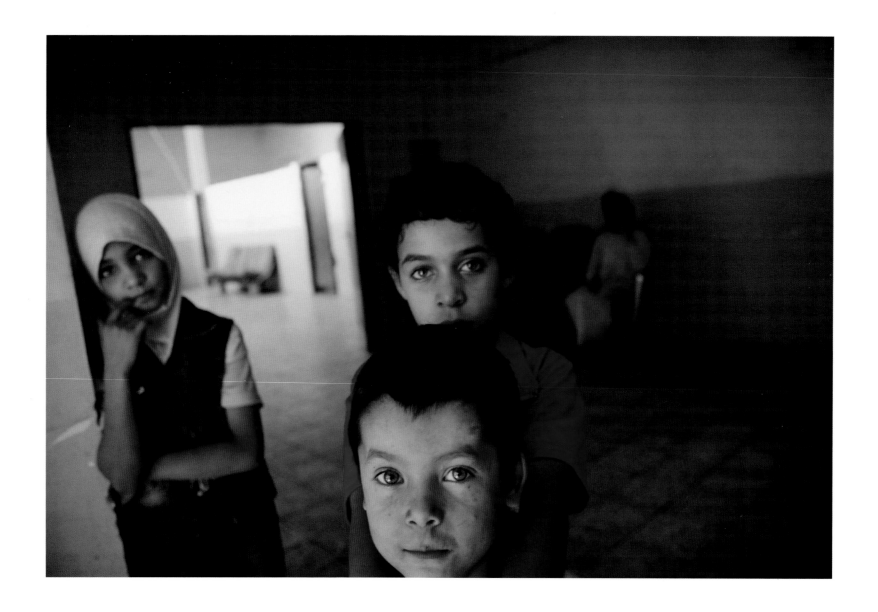

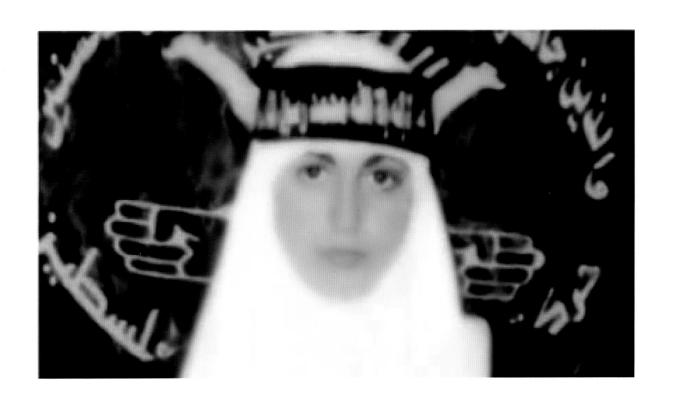

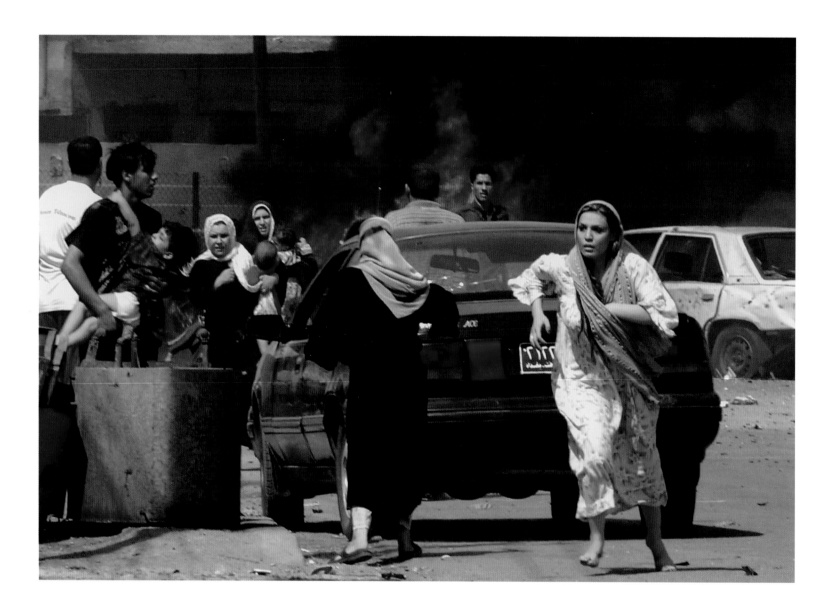

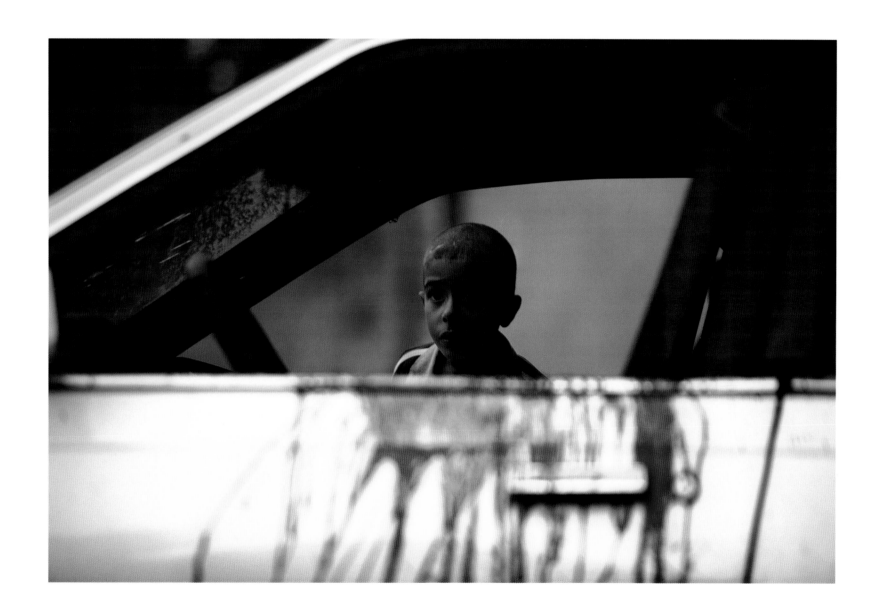

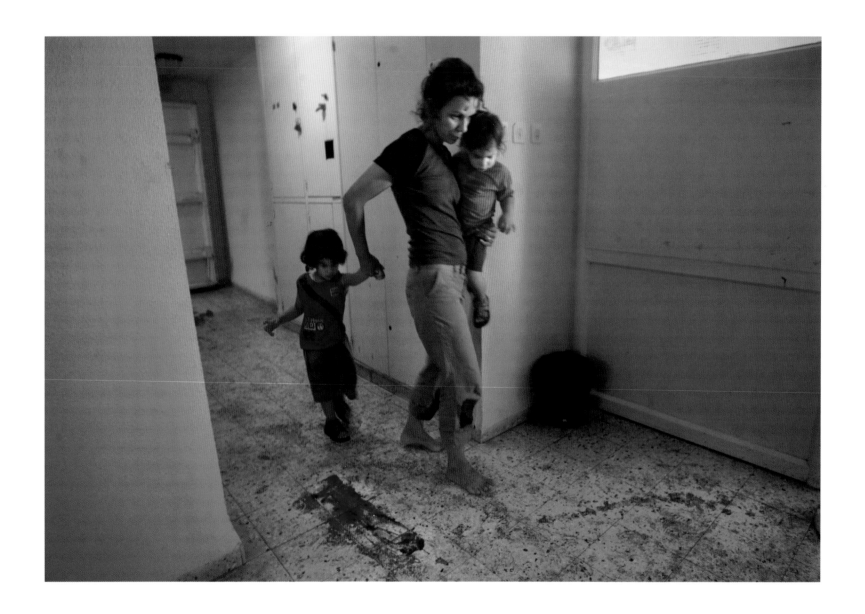

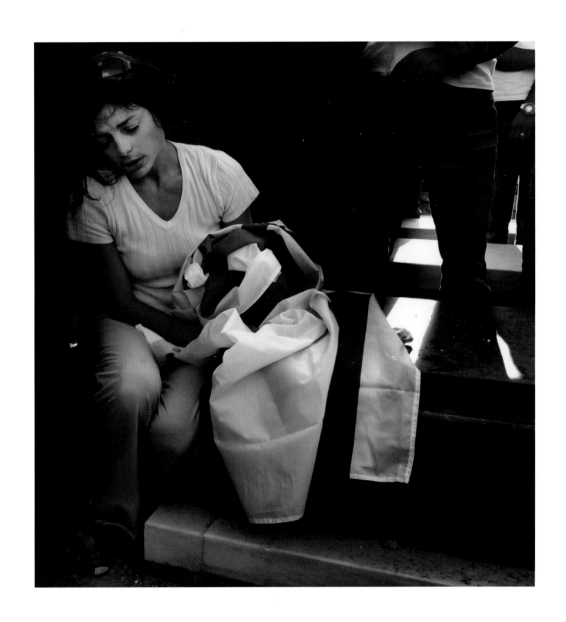

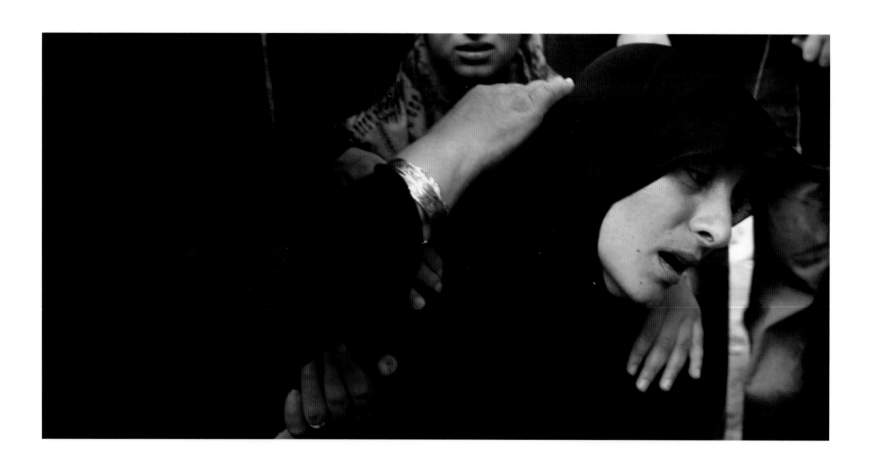

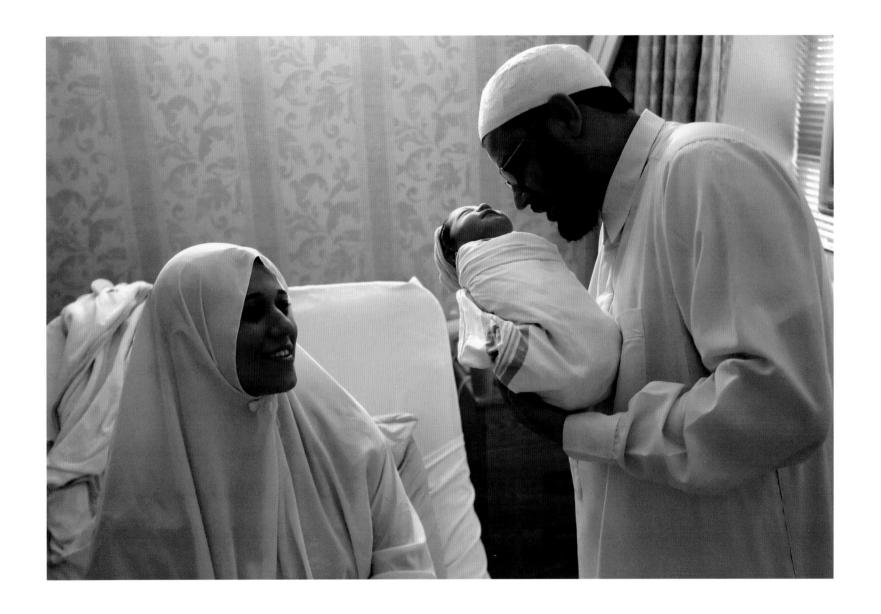

IX. LOVE

Such knowledge has come to many vets too. What they know is this: the world is real; the suffering of others is real; one's actions can sometimes irrevocably determine the destiny of others; the mistakes one makes are often transmuted directly into others' pain; there is sometimes no way to undo that pain—the dead remain dead, the maimed are forever maimed, and there is no way to deny one's responsibility or culpability, for those mistakes are written, forever and as if in fire, in others' flesh.

—Peter Marin

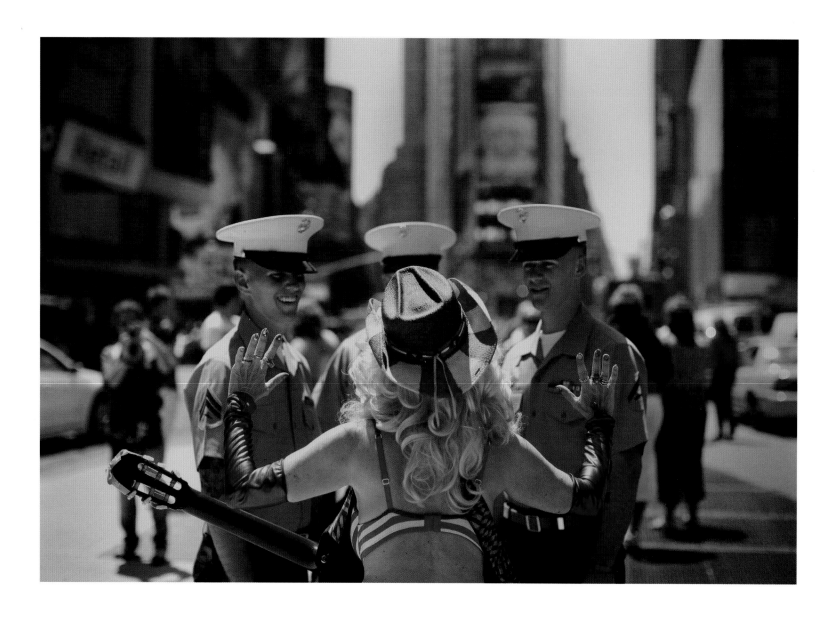

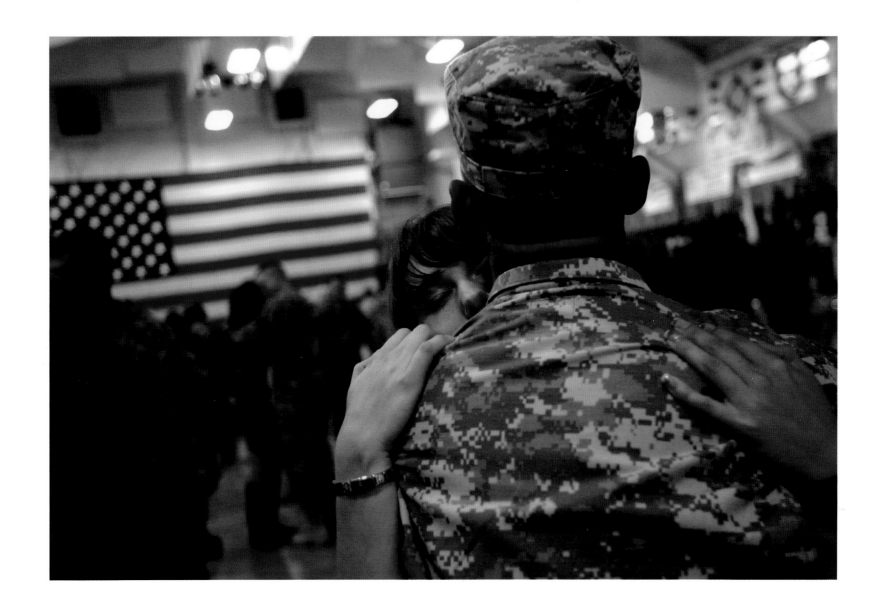

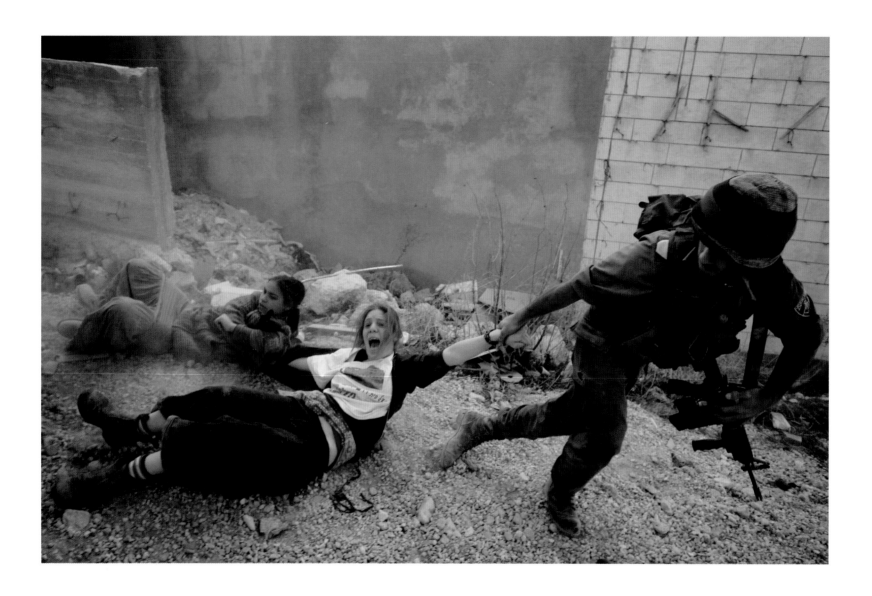

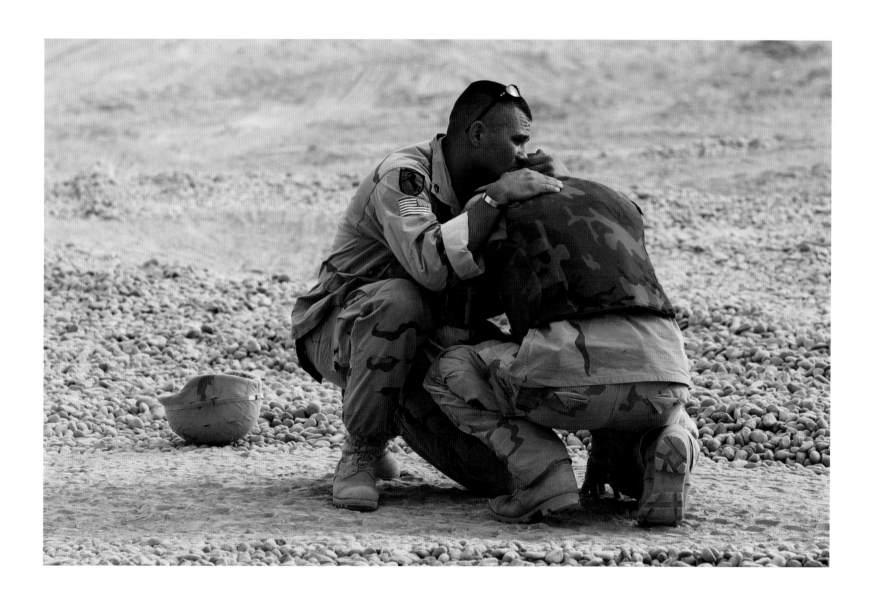

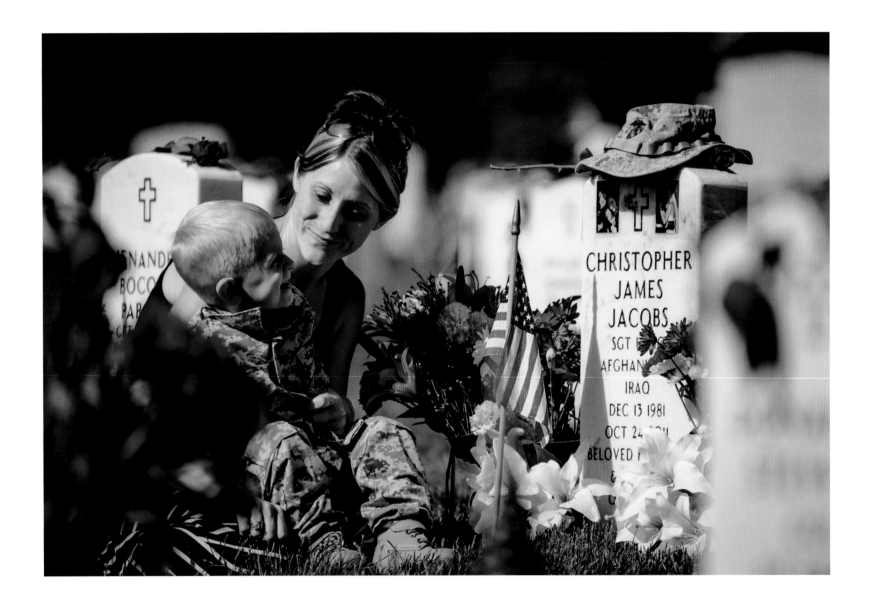

X. DEATH

The New York Times, the Typhoid Mary of American journalism.

—Gore Vidal

Thus for Jefferson the ideal experience of America is one which enables a man to immerse himself temporarily in the wild landscape and then to emerge on a high plane of thought, from which he can analyze the significance of the spectacle below him.

—Richard Slotkin

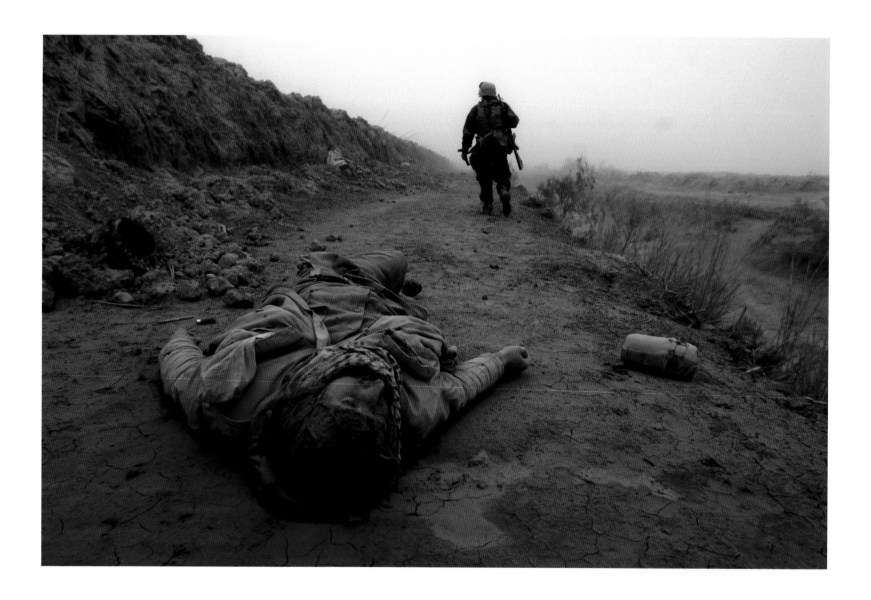

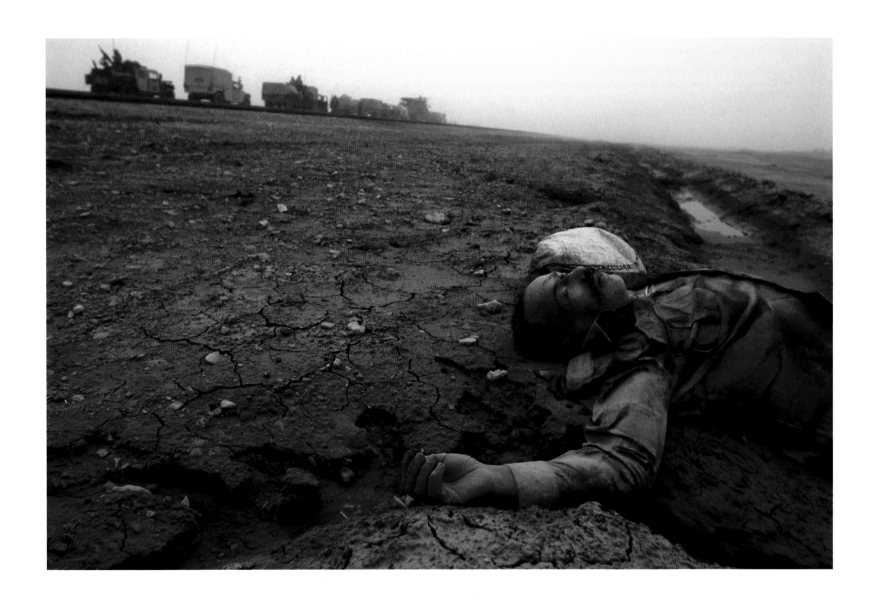

War is Beautiful, They Said

Dave Hickey, from Back Cover

There are vertical divisions based on harmonic scales. Most subtly, there is the seventeenth-century device of framing the image within a square that abuts one short side or the other.

The two best examples of squaring: two soldiers are climbing a curved stairway in a square of light on the right side of the rectangle. On the left, there is a crashed piano and what looks like an El Lissitzky on the wall. (Not a Jewish household, but rather Uday Hussein's palace.) The curve of the ascending staircase and the curve of the fallen piano lid create a pincer design weighted toward the right. The balance is just about perfect. The second weighted square is a photograph of children at a swimming pool. The diving tower, full of children fills the right-hand square, the remaining space on the left is virtually empty. Again, this is a nicely balanced picture available in a hundred variations at the Metropolitan Museum of Art. Other Beaux Arts pantomimes abound. There is a Magdalene in white clothing nodding onto the edge of the frame as she would in a Guido Reni. There is a Rodin of two kneeling marines in a flat field. There are warriors protecting children that echo Imperial Rome, where war was an everyday fact, as the *Times* would seem to wish it now.

Then there are the corrupt cable-news tropes: Soldiers, tanks, and children posed before walls of fire. (Were I a cameraman I would snatch the child from the flames just to avoid the cliché.) Then there are the videogame, industrial-photography tanks in colored atmospheres with a green tech ambience. Crisp silhouettes of helicopters and other war machines are set against Disneyland washes of pastel sky. There are more diagonals than one would wish. There is a Norman Rockwell soldier in camo war paint sitting among a field of his camouflaged comrades (Warhol does Rockwell). Like Rockwell, again, children and beautiful women out-number the combatants depicted by a large margin. All of this is a way of saying that these photographs are very fancy Connecticut-living-room trash, and, just to remind you, combat photography up through Viet Nam used to be good. As a result, at first glance, this book looks like an annual report for Blackwater—whom, you will remember, were purportedly on our side.

Then if you are heading downtown rather than uptown there are dollops of Chelsea. There is a field of flowers cropped to look like a neo "field painting." There are three soldiers in silver light firing off shoulder-fired weapons—echoing Warhol's Elvis paintings. There is a photograph taken in a fabric market with vertical panels of designed fabric—a flat, Robert Rauschenberg rip-off. There are two shell casings photographed from above that evoke Jasper Johns beer cans. There is a Dennis Hopper photograph of a beach, shot from the waterline with an empty chair and water bottle in the center and a line of palms and low buildings in the background. It could be Santa Monica, where I grew up.

The total effect of these photographs is to portray an American industrial project in a desert somewhere with swimming pools, basketball, and baseball being played. Lunch is being served. The commander in chief is giving his soldiers noogies. There is some fire, of course, but we love fire. There are echoes of the elaborate German films and photographs that created a fantasy world of the Russian front where millions were dying. Summing it up, these pictures generate more distrust of American military adventures than I had before, and I had a lot.

Citations

EPIGRAPH:

Edmund Burke, *A Philosophical Enquiry into the Sublime and Beautiful*, James T. Boulton [editor] (New York: Routledge, 2008), 40.

NATURE:

Richard Slotkin, *Regeneration Through Violence: The Mythology of the American Frontier, 1600-1860* (Middletown: Wesleyan University, 1973), 205-206, 176.

PLAYGROUND:

John Hoagland, quoted in interview with Eros Hoagland, in Michael Kamber, *Photojournalists on War: The Untold Stories from Iraq* (Austin: University of Texas, 2013), 111.

Martin van Creveld, *Men, Women, and War* (London: Cassell & Co., 2002), 229-230.

Cormac McCarthy, *Blood Meridian: Or the Evening Redness in the West* (New York: Vintage International, Random House, 2010), 153.

FATHER:

Interview with Farah Nosh in Kamber, *Photojournalists on War*, 202.

C-SPAN, *Q&A* video transcript, November 17, 2010; http://www.c-span.org/video/transcript/?id=8255.

McCarthy, *Blood Meridian*, 152.

Susan E. Tifft and Alex S. Jones, *The Trust: The Private and Powerful Family Behind The New York Times* (New York: Little, Brown and Company, 1999), 155.

GOD:

Wallace Shawn, *Essays* (Chicago: Haymarket, 2010), 82.

PIETÀ:

E. M. Cioran, *Tears and Saints*, translated by Ilinca Zarifopol-Johnston (Chicago: University of Chicago, 1995), 19.

PAINTING:

Gerhard Richter, *Gerhard Richter: Text. Writings, Interviews and Letters, 1961–2007*, Dietmar Elger, Hans-Ulrich Obrist [editors] (London: Thames & Hudson, 2009), 306.

MOVIE:

Ashley Gilbertson, *Whiskey Tango Foxtrot: A Photographer's Chronicle of the Iraq War* (Chicago: University of Chicago, 2007), 192.

BEAUTY:

Roberto Calasso, *The Marriage of Cadmus and Harmony* (New York: Vintage, 1994), 291-292.

LOVE:

Peter Marin, "Living in Moral Pain," in Walter Capps [editor], *The Vietnam Reader* (New York: Routledge, 1991), 47.

DEATH:

Gore Vidal, "Vidal's 'Lincoln': An Exchange," *The New York Review of Books*, August 18, 1988, 67.

Slotkin, *Regeneration Through Violence*, 247.

Photo Captions

All captions attributed to *The New York Times* were created by their reporting or editorial staff to accompany the images as used in print. Original captions are reprinted verbatim from embedded metadata in the original digital photograph as authored by the individual photographer or photo agency.

I. Nature

P. 14 "A convoy from the First Marine Division, hampered yesterday by a sandstorm, took 27 hours to make a trip expected to take 8 to 12 hours."
The New York Times, March 26, 2003
> ORIGINAL: A severe sandstorm blanketed a convoy from the Headquarters Battalion of the 1st Marine Division north of the Euphrates River in Iraq, on March 25, 2003. President Barack Obama announced Oct. 21, 2011, that the United States had fulfilled its commitment in Iraq and would bring all U.S. troops home by the end of the year.

P. 15 "A German soldier burned a flare in the desert while on patrol in Afghanistan's Kunduz Province, where the insurgency is growing."
The New York Times, October 27, 2009
> ORIGINAL: A German soldier holds a flare as his platoon sets up camp near Kunduz, Afghanistan, on Oct. 21, 2009. Forced to confront the rising insurgency in once-peaceful northern Afghanistan, the German army is now fighting and killing on a scale it has not seen since World War II.

P. 16 "Along the Euphrates River, American marines and members of the Iraqi National Guard searched for weapons caches stockpiled by insurgents."
The New York Times, November 29, 2004
> ORIGINAL: 28 November 2004. . .Yusufiya, Iraq. . .Operation "Plymouth Rock"/ Amphibious landing. . .U.S. Marines and Iraqi National Guard executed the largest ever amphibious landing to take place in Iraq today 28 November in the area of Yusufiya as part of operation "Plymouth Rock" aimed at targeting insurgent and criminal groups. After a dawn insertion in gunboats, the combined forces made a sweep through palm groves, orchards, and farmland searching for hidden weapons.

P. 17 "An Army officer walking through a poppy field while on patrol in Afghanistan last month."
The New York Times, May 27, 2012
> ORIGINAL: A U.S. Army Officer from 5-20 infantry Regiment attached to 82nd Airborne walks through a poppy field while on patrol in Zharay district in Kandahar province, southern Afghanistan April 26, 2012.

P. 18 "UNDER ATTACK: Specialist Robert Soto ran for cover last week as his platoon was ambushed in Afghanistan. Across the river, two comrades crouched behind a rock."
The New York Times, April 20, 2009
> ORIGINAL: Immediately following an IED explosion, Spcl. Robert Soto of the U.S. Army 2nd Platoon, B Company 1-26 runs for cover in Korengal Valley, Kunar Province, Afghanistan as Taliban fighters attack from multiple locations during an ambush on April 15, 2009.

P. 19 "Duty in Afghanistan includes not just patrols, but also the sweaty, unglamorous everything else of being in the infantry."
The New York Times, November 22, 2010
> Clockwise from top left:
> ORIGINAL: 1.6.1
> On patrol to clear an exit out of the village of Nahr-i-Sufi in Kunduz, Afghanistan, U.S. soldiers from 2nd Platoon, Delta Company, First Battalion, 87th Infantry Regiment

come upon an ambush setup for the Americans, leading to an hour-long gunfight, Oct. 11, 2010. For G.I.s, frontline life is a life of wild pendulum swings. One moment, their sergeants are barking at them to stay ready, eyes focused, rifles loaded, protective gear at hand. In the next, the soldiers are searching for amusement, killing time with the skill of people who have had plenty of practice.

ORIGINAL: 1.6.2
Pfc. Nicholas Hollman shakes dirt off his pants after pulling guard duty on a roof at a compound position in the village of Nahr-i-Sufi in Kunduz, Afghanistan, Oct. 11, 2010. For G.I.s, frontline life is a life of wild pendulum swings. One moment, their sergeants are barking at them to stay ready, eyes focused, rifles loaded, protective gear at hand. In the next, the soldiers are searching for amusement, killing time with the skill of people who have had plenty of practice.

ORIGINAL: 1.6.3
Pfc. Christopher Daniel, left, wrestles Pvt. Ricardo Santiago outside during downtime at a compound position in the village of Nahr-i-Sufi in Kunduz, Afghanistan, Oct. 11, 2010. For G.I.'s, frontline life is a life of wild pendulum swings. One moment, their sergeants are barking at them to stay ready, eyes focused, rifles loaded, protective gear at hand. In the next, the soldiers are searching for amusement, killing time with the skill of people who have had plenty of practice.

ORIGINAL: 1.6.4
U.S. Army soldiers gather together to share each other's body heat during the coldest time of the morning at a compound position in the village of Nahr-i-Sufi in Kunduz, Afghanistan, Oct. 11, 2010. For G.I.'s, frontline life is a life of wild pendulum swings. One moment, their sergeants are barking at them to stay ready, eyes focused, rifles loaded, protective gear at hand. In the next, the soldiers are searching for amusement, killing time with the skill of people who have had plenty of practice.

II. Playground

P. 22 "Cooling off in Baghdad an American soldier monitored the scene Wednesday at a newly renovated pool in Baghdad. Iraq's foreign minister said that negotiations on a long-term agreement about the status of American forces might not be completed by the end of the year."
The New York Times, July 3, 2008
> ORIGINAL: A U.S. soldier looks at children swimming in a newly renovated pool in Baghdad's Adhamiya district July 2, 2008.

P. 23 "Training is rigorous, like that in an American boot camp. A camp near Baghdad, above."
The New York Times, June 13, 2005
> ORIGINAL: In a training facility outside Baghdad, Iraqi Special Operation Forces are trained by American and Iraqi instructors.

P. 24 "DRILLING FOR WAR: Soldiers in the British First Battalion Parachute Regiment practiced driving all-terrain vehicles in Kuwait. The American-led coalition may invade Iraq even before all allied troops arrive.
The New York Times, March 16, 2003
> ORIGINAL: Soldiers from the 1st Battalion The Parachute Regiment practice driving all terrain vehicles in the Kuwaiti desert.

P. 25 "Luring a Sniper in Najaf, Amid Signs of a Thaw: A United States Army soldier used a dummy head to try to draw a sniper into view in Najaf yesterday. There were signs that

the grip of the rebel cleric Moktada al-Sadr on the Imam Ali mosque was weakening."
The New York Times, August 21, 2004

ORIGINAL: A U.S. Army soldier uses a dummy to draw a sniper into view in Najaf, Iraq, Friday, Aug. 20, 2004. Later on Friday, militiamen loyal to rebel Shiite cleric Muqtada al-Sadr removed their weapons from the revered Imam Ali Shrine in Najaf as part of an effort to end 2-week-old uprising centered on the holy site. This photograph is one in a portfolio of twenty taken by eleven different Associated Press photographers throughout 2004 in Iraq. The Associated Press won a Pulitzer prize in breaking news photography for the series of pictures of bloody combat in Iraq. The award was the AP's 48th Pulitzer.

P. 26 "PURPLE HEARTS: Dawn Halfaker, left, working out with Sgt. Robert Falk, a physical therapist at Walter Reed Army Medical Center. She and Danielle Green, right, both former basketball players, were among the first women to lose limbs while earning Iraq campaign ribbons."
The New York Times, April 10, 2005

ORIGINAL: WASHINGTON—April 9, 2005—SOLDIERS-ATHLETES—Iraq war veteran Lieutenant Dawn Halfaker, right, from Ramona, Calif., who lost her right arm during a rocket-propelled grenade attack in Iraq, works Sgt. Robert Falk, a physical therapist, at the Walter Reed Medical Center in Washington, Friday, March 4, 2005. Halfacker was once a four-year starter for West Point's basketball team.

P. 27 "Pfc. Antonio McEwen, at the plate this month in Iraq, uses sports to calm his nerves so he can better handle tense work amid trash-strewn streets."
The New York Times, August 19, 2005

ORIGINAL: For members of the 467th Engineer Battalion operating in Iraq, Forward Operating Base Camp Warhorse offers sports as a way of escaping from the emotional turmoil of war. Soldiers returning from dangerous patrols on the streets of Iraq can engage in any number of activities to get their minds off the war, from volleyball and basketball, to weight training and softball. ///Private Antonio McEwen swings at a ball during a game of softball with soldiers in his unit, the 467th Engineer Battalion.

III. Father

P. 30 "Arnold Rist, 86, with Thomas Cahill, 3, at the Memorial Day parade in Stony Point, N.Y., on Monday. Mr. Rist played taps, as he had many hundreds of times at military funerals. In April 1945, he helped liberate the inmates of the Dachau concentration camp."
The New York Times, May 31, 2011

ORIGINAL: Arnold Rist, 86, with Thomas Cahill, 3, at the Memorial Day parade in Stony Point, N.Y., on Monday. Mr. Rist played taps, as he had many hundreds of times at military funerals. In April 1945, he helped liberate the inmates of the Dachau concentration camp.

P. 31 "CROSSFIRE: A marine doctor held an Iraqi girl yesterday after her mother was killed by crossfire on the front line near Rifa, American officers said."
The New York Times, March 30, 2003

ORIGINAL: U.S. Navy Hospital Corpsman HM1 Richard Barnett, assigned to the 1st Marine Division, holds an Iraqi child in central Iraq in this March 29, 2003 file photo. Confused front line crossfire ripped apart an Iraqi family after local soldiers appeared to force civilians towards positions held by U.S. Marines. March 20 marks the one-year anniversary of the beginning of the U.S. led war against Iraq. The war started on March 20 Baghdad local time, March 19 Washington D.C. local time.

P. 32 "Seeking Shelter Where He Can Find It: An Iraqi boy hid behind a U.S. soldier yesterday amid gunfire after a car bomb in Central Baghdad killed 24 people. In the Green Zone, U.S. and Iranian officials held a rare meeting, focusing on the war."
The New York Times, May 29, 2007

ORIGINAL: In this May 28, 2007 file photo, a young boy seeks shelter behind a soldier with the U.S. Army's 82nd Airborne division after gunshots rang out at the scene where just a few minutes earlier a suicide car bomber blew himself up in a busy commercial district in central Baghdad killing at least 21 people and wounding 66. In the beginning, it all looked simple: topple Saddam Hussein, destroy his purported weapons of mass destruction, and lay the foundation for a pro-Western government in the heart of the Arab world. Nearly 4,500 American and more than 100,000 Iraqi lives later, the objective now is simply to get out and leave behind a country where democracy has at least a chance, where Iran does not dominate, and where conditions may not be good but "good enough."

P. 33 "Bush Greets G.I.'s and Flies Over Baghdad President: Bush rubbed Staff Sgt. Michael Brown's head during a visit yesterday with troops in Doha, Qatar. Mr. Bush said the former Iraqi government was 'capable of producing biological agents.'"
The New York Times, June 6, 2003

ORIGINAL: U.S. President George W. Bush reaches to rub the head of Staff Sgt. Michael Brown after delivering remarks at Camp As Sayliyah Thursday June 5, 2003 in Doha, Qatar.

IV. God

P. 36 "The Israelis Disarm A Boy With a Bomb: With a bomb hidden under his sweater, a Palestinian boy in his teens, Hussam Abdo, approached Israeli soldiers yesterday at the same West Bank checkpoint, near Nablus, where last week another boy was captured with a bomb in his bag. As an Associated Press TV cameraman, who also happened to be waiting at the checkpoint, recorded the scene, the soldiers made the youth reveal the explosives, and then strip. They seized the boy and later safely detonated the bomb."
The New York Times, March 25, 2004

ORIGINAL: Israeli soldiers question a Palestinian boy who was caught with an explosive belt at a checkpoint at the entrance to the Palestinian West Bank city of Nablus March 24, 2004. Israeli troops arrested the 14-year-old Palestinian would-be suicide bomber at a West Bank checkpoint before he could detonate his explosive belt, the army said.

P. 37 "In Falluja, an Iraqi thanked Cpl. Joseph Sharp after he and other marines delivered food and water to civilians. American officials agreed to call off an offensive in Falluja if local leaders can persuade guerrillas to turn in their heavy weapons."
The New York Times, April 20, 2004

ORIGINAL: An Iraqi civilian kisses the hand of U.S. Marine Cpl. Joseph Sharp from Peoria, Ill., after Marines from the 1st Battalion 5th Marines gave him a supply of food and water in Fallujah, Iraq, Monday, April 19, 2004.

P. 38 "On patrol over Baghdad, Specialist Richard Harvey, a gunner on a Black Hawk helicopter, watches out below."
The New York Times, November 17, 2003

ORIGINAL: Spc. Richard Harvey hangs out the gunners door as he attempts to get a better view of the streets below, which are sometimes as close as 100 feet above Baghdad, Iraq, Nov. 16, 2003.

P. 39 "Senator Barack Obama arrived in Iraq on Monday and was given an aerial tour of Baghdad by Gen. David H. Petraeus."
The New York Times, July 22, 2008
ORIGINAL: BAGHDAD–JULY 21: In this handout photo released by the U.S. Army, U.S. Army Gen. David H. Petraeus (R), commander of the Multi-National Force in Iraq, speaks with presumptive Democratic presidential candidate Sen. Barack Obama (D-IL) during an aerial tour July 21, 2008 in Baghdad, Iraq. Sen. Chuck Hagel (R-NE) and Sen. Jack Reed (D-RI) joined the presidential candidate on his tour of the Middle East and Europe.

V. Pietà

P. 42 "FIREFIGHTS NEAR SHIITE SHRINES: An American soldier guarded a mosque yesterday in Karbala, Iraq, as troops parried with insurgents there and in Najaf. Three Muslim saints are pictured above the door."
The New York Times, May 15, 2004
ORIGINAL: American soldiers from the 1st Armored Division raid a mosque in Karbala, Iraq on May 14, 2004. The men kept clear of doors and windows due to heavy mortar fire and precision sniping during the raid, which netted two R.P.G.s, six rockets, and small arms ammunition. The mosque was wired with C-4 explosive and destroyed so it could not be used in the future by Muqtada al-Sadr's Mahdi army. The poster above the door depicts Imam Abbas, Imam Ali, and Imam Hussein—sacred prophets in Shiite Islam.

P. 43 "At Least 10 Palestinians Die When Israelis Open Fire in Gaza: Israeli troops fired rockets yesterday during a protest march by Palestinians in Rafah, in southern Gaza, killing at least 10, including several children. A Palestinian man carries one of the dead children. The Gazans were protesting raids by Israeli troops seeking weapons."
The New York Times, May 20, 2004
ORIGINAL: Palestinian man carries a dead boy killed when Israeli forces opened fire on a protest march at the Rafah refugee camp in southern Gaza Strip May 19, 2004. Israeli forces killed eight Palestinians in an attack on a crowd of people in Rafah, Palestinian witnesses and medics said.

P. 44 "A Georgian man wept over the body of a relative on Saturday after Russian airstrikes in Gori hit two apartment buildings."
The New York Times, August 10, 2008
ORIGINAL: A Georgian man cries near the body of his relative after a bombardment in Gori, 80 km (50 miles) from Tbilisi, August 9, 2008. A Russian warplane dropped a bomb on an apartment block in the Georgian town of Gori on Saturday, killing at least 5 people, a Reuters reporter said. The bomb hit the five-story building in Gori close to Georgia's embattled breakaway province of South Ossetia when Russian warplanes carried out a raid against military targets around the town.

P. 45 "Soldiers protected a comrade as a helicopter landed nearby; below, a medic bandaged the soldier, hit by shrapnel. Iraqi insurgents are putting bombs along footpaths and back roads."
The New York Times, May 23, 2007
ORIGINAL: Latafiya, Iraq May 19, 2007 Alpha Co. 2-15, Task force 2-15, 2nd Brigade Combat Team, 10th Mountain Division. Soldiers cover a wounded comrade on a stretcher to keep debris off of him that is being kicked up by a medevac chopper landing nearby. Standing at left in t-shirt is another wounded soldier being supported by comrades. Scenes from a combat patrol today that ended in tragedy when one U.S. soldier was killed and four wounded (3 U.S., 1 I.A.) when the KIA either stepped on a pressure activated land mine or was killed by a command detonated IED buried along a dirt road where the patrol was walking. The soldiers were taking part in the search for the three U.S. soldiers captured several days ago. The patrol continued

with several other groups of U.S. and Iraqi soldiers and another U.S. soldier was shot in the forehead by an Iraqi sniper and critically injured at another location during the search.

P. 46 "Ali Hadi, a professional body washer, prepared the body of a bombing victim for proper Muslim burial in Najaf while the man's relatives watched."
The New York Times, March 4, 2004
ORIGINAL: In this photo by Joan Silva, Ali Hadi, a professional body washer, prepares the body of a bombing victim for Muslim burial as the man's relatives watch in Najaf, Iraq, on March 3, 2004. Silva was severely wounded on Oct. 23, 2010, when he stepped on a mine while on patrol with American soldiers in southern Afghanistan.

VI. Painting

P. 50 "Israeli armored personnel carriers entered Gaza after dawn yesterday."
The New York Times, July 7, 2006
ORIGINAL: ZIKIM, ISRAEL: A column of armored personnel carriers (APC) crosses the Israeli border into the Gaza Strip at sunrise, 06 July 2006, from the nearby Kibbutz of Zikim. Israeli tanks moved deeper into the northern Gaza Strip today, effectively establishing a new buffer zone after attacks from improved Palestinian rockets are now able to reach further into Israel.

P. 51 "Marines tried to take cover after a phosphorus round, set off to help provide cover for tanks, rained down on the unit. No one was seriously hurt."
The New York Times, November 10, 2004
ORIGINAL: Marines run for cover after white phosphorus was accidentally fired at them by another company when Bravo Company, 1st Battalion, 8th Marine Regiment, was somehow mistaken for a band of insurgents in Falluja, Iraq on Nov. 9, 2004. No one was hurt, but a 4000 degree briquette burnt right through Dexter Filkins' backpack. It was horrible taking cover on the ground lying face up—face down meant I couldn't dodge the pieces falling from the sky.

P. 52 "Dust Storm Shuts Down Baghdad: Most Baghdad streets were empty yesterday during a dust storm that many residents described as the worst they had seen in years."
The New York Times, August 9, 2005
ORIGINAL: A sandstorm is filling the air over Baghdad with very fine powdery dust. A woman is crossing the street in Baghdad's Karada neighborhood.

P. 53 "PALACE OF RUBBLE: American soldiers yesterday inside a ruined palace in Baghdad that belonged to President Saddam Hussein's son Uday."
The New York Times, April 11, 2003
ORIGINAL: BAGHDAD, Iraq—April 10, 2003—IRAQ-BAGHDAD-8—American soldiers patrol inside a palace which belonged to Uday Hussein in Baghdad, Thursday, April 10, 2003. The palace was heavily bombed by coalition airpower.

P. 54 "A view from a joint American-Iraqi military observation post in Ramadi, in Anbar Province. Local Sunni tribes have helped to calm the area by working with the American military."
The New York Times, April 29, 2007
ORIGINAL: A view of civilian foot traffic from a joint U.S.-Iraqi Army observation post in Ramadi, Anbar province, Iraq—April 8, 2007. For the past three years, the area in and around Ramadi, has been the stage for fierce violence and combat until recently—now that many local Sunni tribes are cooperating with U.S. forces, and the Iraqi Police have dramatically increased in number and effectiveness, the region known as the "wild west" is showing strong signs of pacification, but there are doubts as to how long the calm will last.

P. 55 "Shamali refugees have been living in the ruins of the Soviet Embassy in Kabul for several years."
The New York Times, January 7, 2002
 ORIGINAL: KABUL, Afg.—Jan. 6, 2002—AFGHAN-DESTRUCTION—The people of the Shamali Plain, which stretches north from Kabul to the mouth of the Pansjhir Valley, proudly resisted the Taliban for years, and they paid an extraordinarily high price. Some of the methodical savagery had an ethnic cast. Most of the Shamali people were Tajiks, who showed little inclination to be subjugated by the Pashtun Taliban. Today, their region shows little but destruction. Shamali refugees in the ruins of the Soviet Embassy in Kabul last week, where they have been living for several years.

P. 56 "Israeli Troops and Police Clear All but 5 Gaza Settlements: Neve Dekalim, once the largest Israeli settlement in Gaza, was nearly deserted yesterday, after forces had removed all but a few families.
The New York Times, August 20, 2005
 ORIGINAL: NEVE DEKALIM, Gaza Strip—Aug. 19, 2005—MIDEAST-GAZA-8—The Jewish settlement of Neve Dekalim in Gaza is virtually deserted on Friday morning, Aug. 19, 2005. After more than a year of political dramas and anguished debates, Israel's withdrawal from the Gaza Strip is proceeding far more quickly and with much less turmoil than most anyone had predicted.

P. 57 "An unidentified sister of Rajah Ibrahim, who was killed by militants on accusations of collaborating with Israel, hiding yesterday behind a curtain placed at the entrance to the family home in Tulkarm."
The New York Times, September 2, 2002
 ORIGINAL: TULKAREM, West Bank—September 1, 2002—MIDEAST-EXECUTE—On Friday, the 17-year-old daughter of 43-year-old Muyasar Ibrahim, Rajah Ibrahim, was shot dead, apparently by Al Aqsa Martyrs Brigades for collaboration with the Israelis. Six days earlier, Muyasar Ibrahim's sister, 35-year-old Ikhklas Khouli, had been similarly killed. Six months earlier, Ibrahim's husband was killed. Ikhklas Khouli and Rajah Ibrahim had the distinction of being the first women killed in the current Palestinian uprising, and their deaths have attracted considerable attention. The sister of Raja Ibrahim hides behind a curtain Sunday, placed at the entrance to the Tulkarem, West Bank house to protect the family.

P. 58 "Iranian-made cartridges recovered from the northern Ivory Coast, of a type found in several African countries."
The New York Times, January 1, 2013
 ORIGINAL: Iranian 7.62 x 39 mm cartridge recovered from northern Côte d'Ivoire, documented in 2009.

P. 59 "High Death Tolls in Afghanistan and Iraq: In Kabul, Afghanistan, above, and in Iraq, civilians were under particularly fierce attack yesterday. Two bombings in Iraq left 23 people dead, and two American soldiers were killed. In Afghanistan, three bombings killed 18 people, including four Canadian soldiers."
The New York Times, September 9, 2006
 ORIGINAL: French soldiers arrive to the scene where a car bomber killed three Afghan police and wounded five people in Kabul, Afghanistan, Monday, Sept. 18, 2006. A suicide car bomber killed three Afghan police and wounded five other people in Kabul on Monday, an official said.

VII. Movie

P. 62 "With the nation on a high state of alert, Secret Service officers watched over the White House yesterday from the Old Executive Office Building."
The New York Times, September 11, 2002

 ORIGINAL: With the nation on a high state of alert, Secret Service officers watched over the White House yesterday from the Old Executive Office Building.

P. 63 "Specialist Brandon Conger went to a compulsory financial briefing at Fort Benning and found salesmen in charge."
The New York Times, July 20, 2004
 ORIGINAL: FT. BRAGG, North Carolina—July 19, 2004—SOLDIERS-INSURE-2—Brandon Conger prepares for a training exercise at Ft. Bragg, N.C. A six-month examination by *The New York Times*, drawing on military and court records and interviews with dozens of industry executives and servicemen and women, has found that a number of financial services companies or their agents are using questionable tactics on military bases to sell insurance and investments of doubtful suitability to the people in uniform who buy them.

P. 64 "American forces, arriving in Kuwait in one of the last convoys out of Iraq, took the same highway they came in on in 2003."
The New York Times, December 16, 2011
 ORIGINAL: American forces arriving in Kuwait in one of the final convoys out of Iraq, Dec. 3, 2011. Stories and images are always new, no matter how old the theme. The surprise of the world is that it can still surprise us.

P. 65 "Smoke billowed from burning tires as a Syrian rebel fired toward government forces during clashes in Aleppo on Tuesday."
The New York Times, November 14, 2012
 ORIGINAL: Smoke billows from burning tires as a Syrian rebel of the Halab al-Shabah battalion under Al-Tawhid brigade fires towards regime forces during clashes in Al-Amariya district of the northern city of Aleppo on November 13, 2012. Fierce battles and army shelling in and near Damascus killed at least 41 people, mostly civilians, the Britain-based Syrian Observatory for Human Rights said, as warplanes launched more air raids on a town on the Turkish border.

P. 66 "Israeli soldiers fired rubber bullets at Palestinian stone throwers in the West Bank town of Al Ram, near East Jerusalem, last month."
The New York Times, March 8, 2012
 ORIGINAL: Israeli soldiers fire their rifles during clashes with Palestinian stone throwers demonstrating in the West Bank neighborhood of Al-Ram, adjacent to Israeli-annexed east Jerusalem, on February 26, 2012. The clashes erupted after a Palestinian wounded by Israeli army gunfire at al-Ram died in hospital on February 24th, a day of clashes in and around the holy city of Jerusalem.

P. 67 "Fire in the Night: Soldiers of the United States Special Forces firing antitank weapons yesterday on a range outside of Khost, Afghanistan. American troops continue to seize weapons and search for Taliban and Qaeda suspects."
The New York Times, August 31, 2008
 ORIGINAL: A member of the U.S. Army Special Forces ODA 924 is silhouetted as another two fire AT-4 antitank weapons on a firing range Friday evening, Aug. 30, 2002, on the outskirts of Khost, 130 kms (80 miles) southeast of the Afghan capital of Kabul. U.S. Army Special Forces are the forefront of the military coalition's attempt to route out the country's remaining al-Qaida and Taliban forces as well as decades worth of weapons and ammunitions.

P. 68 "Near Karbala early today, a mobile artillery piece from the Army's Third Division fired toward Iraqi troops."
The New York Times, April 2, 2003
 ORIGINAL: KARBALA, Iraq—U.S. forces fire on Iraqi Republican Guard units near Karbala on April 2.

P. 69 "A heavily guarded compound close to the Ministry of Foreign Affairs beside the Tigris River in Baghdad burned after it exploded in a fireball last night as bombs and missiles hit."
The New York Times, March 21, 2003
> ORIGINAL: A heavily guarded compound close to the Ministry of Foreign Affairs beside the Tigris River in Baghdad burned after it exploded in a fireball last night as bombs and missiles hit.

P. 70 "A CH-46 Sea Knight transport helicopter over Baghdad yesterday. One helicopter of that model crashed yesterday, killing seven people."
The New York Times, February 8, 2007
> ORIGINAL: In a file photo a U.S. Army CH-46 Sea Knight helicopter files over Baghdad's heavily fortified Green Zone, Iraq, Wednesday, Feb. 7, 2007. A Sea Knight helicopter that crashed last week northwest of Baghdad was shot down, the U.S. military said Wednesday, Feb. 14, 2007. Military officials initially said they did not believe it was downed by insurgents.

P. 71 "In Baghdad, Off With His Heads: American copters flew nearby yesterday as workers dismantled giant busts of Saddam Hussein. In Hawija, U.S. forces mounted raids."
The New York Times, December 3, 2003
> ORIGINAL: U.S. helicopters overfly the area as workers dismantle one of the four giant bronze busts of Saddam Hussein that have long dominated Baghdad's skyline, in yet another move aimed at eradicating the former leader's influence in Baghdad, Tuesday, Dec. 2, 2003. Workers using a construction crane are seen atop one of the four statues, right, of a glowering Saddam wearing a tropical helmet that have adorned the Republican Palace since the 1980s. The U.S.-led Coalition Provisional Authority moved into the palace in May after the fall of Baghdad.

P. 72 "For some soldiers of the First Battalion, 87th Infantry, returning after their yearlong deployment to Afghanistan was the beginning of new difficulties."
The New York Times, May 29, 2011
> ORIGINAL: KUNDUZ, AFGHANISTAN—Soldiers prepared to board their transport helicopter to leave FOB Kunduz Sunday March 06, 2011.

P. 73 "Factions Battle in the Streets of Gaza: A Palestinian boy stood near clashes between Hamas and Fatah in Gaza City yesterday. The fighting has left at least nine Palestinians dead since Sunday, and the Palestinian interior minister resigned."
The New York Times, May 15, 2007
> ORIGINAL: GAZA CITY: A Palestinian youth stands in front of a burning vehicle during clashes between rival Fatah and Hamas in Gaza City, 14 May 2007. Two Palestinians were killed in fresh fighting between rival Fatah and Hamas gunmen today despite a truce aimed at ending the worst factional violence since a unity government took office.

VIII. Beauty

P. 76 "Pashtuns young and old have been forced out of their villages and now live in caves in northern Afghanistan."
The New York Times, March 7, 2002
> ORIGINAL: A Pashtu girl and an old woman live in caves in Gartepa after being forced from their villages in Faryab Province.

P. 77 "A Favorite Didn't Win a Nobel: A chemical weapons watchdog won the Nobel Peace Prize on Friday, although one favorite had been a young Pakistani advocate for the education of girls like these near Islamabad."
The New York Times, October 12, 2013

> ORIGINAL: Girls attend lessons at a school in a slum on the outskirts of Islamabad October 11, 2013.

P. 78 "At Al Rahma shelter for homeless women and children, clockwise from left: Fatima, Sahar and Daif."
The New York Times, May 23, 2006
> ORIGINAL: May 12, 2006, Baghdad, Iraq: The 'Al-Rahma Institution for Orphans and Homeless Children' was founded by Dr. Suad Mehdi Said Al-Khafgi in August of 2004. The organization assists boys up to 12 years of age and girls and women of all ages. The Iraqi government has registered some 5,000 private organizations including charities, human rights groups, and medical assistance agencies since the 2003 invasion. These non-governmental organizations (NGO) are charged with filling the public and social services gap brought about by the ongoing war. ///Orphans, Fatima (L), 10, Daif (C), 10 and Sahar (front), 7.

P. 79 "Hiba Daraghmeh, the first Palestinian woman to blow herself up on behalf of an Islamist group."
The New York Times, May 30, 2003

P. 80 "Iraqis fled the scene yesterday after car bomb explosions at a street celebration of the opening of a sewage plant in Baghdad. Two bombers drove their cars into crowds of children waiting to receive candy from G.I.'s."
The New York Times, October 1, 2004
> ORIGINAL: BAGHDAD, IRAQ—SEPTEMBER 30: Iraqi citizens flee the scene after three explosions September 30, 2004 in Baghdad, Iraq. Three separate explosions near a U.S. military convoy which was passing the opening ceremony for a sewage station killed at least 35 people and wounded more than 100 others in southern Baghdad according to Iraqi police.

P. 81 "An Iraqi boy peered yesterday inside a car that was towed to a Baghdad police station after two women inside were killed."
The New York Times, October 10, 2007
> ORIGINAL: A boy looks through the window of a car where two women were killed in central Baghdad, Tuesday, Oct. 9, 2007. The women were killed when a security convoy of white sport utility vehicles opened fire on the sedan carrying four people, witnesses and police officials said. The incident comes at a high point of tension between the Iraqi and American governments over the issue of private security companies that operate inside Iraq but are protected from Iraqi law.

P. 82 "A woman and two children at the scene of an attack in Acre, Israel. Five Israelis, including a man and his daughter, were killed there yesterday."
The New York Times, August 4, 2006
> ORIGINAL: A woman walks with two children past blood on the floor at the scene of a rocket attack in the northern Israeli city of Acre August 3, 2006. Hizbollah guerrillas killed eight people in Israel in a rocket barrage on Thursday despite an intensive Israeli ground and air campaign to wipe them out, as world powers struggled to end the 23-day-old war.

P. 83 "THE VICTIMS: A cousin of Bat-El Ohana, 21, who died in the Jerusalem bus bombing, held the Israeli flag that had covered her coffin in Kiryat Ata, Israel. In a Gaza City mosque, Palestinians prayed over nine draped bodies of people killed in an Israeli helicopter raid on Wednesday."
The New York Times, June 13, 2003
> ORIGINAL: KIRYAT ATTA, Israel—June 12, 2003—MIDEAST-4—Sarit, a cousin of Bat-El Ohana, 21, holds the Israeli flag that covered her coffin, as she mourns during her funeral in the cemetery of Kiryat Ata, near the northern city of Haifa, Israel, Thursday, June 12, 2003. Ohana, 21, was one of 16 people killed in Wednesday's bus bombing in Jerusalem.

P. 84 "Lebanese, Returning to the South, Mourn Their Dead"
The New York Times, August 19, 2006
> ORIGINAL: QANA, Lebanon—Aug. 18, 2006—MIDEAST-LEBANON-13—Mourners grieve during a mass funeral service in Qana, southern Lebanon, on Friday, Aug. 18, 2006. Many of those buried Friday were killed in an Israeli airstrike on an apartment building July 30th which killed over a dozen children. Also buried Friday in the burial service were Hezbollah fighters.

P. 85 "'Married life in Islam is an act of worship' Sheik Reda Shata, who promotes marriage and blesses the newborn in his work as an imam"
The New York Times, March 7, 2006
> ORIGINAL: NEW YORK—March 6, 2006—BROOKLYN-IMAM-III—Sheik Reda Shata blesses a newborn Macin Elrafey as his mother Marwa Elrafey looks on at Victory Memorial Hospital in the Brooklyn borough of New York on Aug. 4, 2005. Shata promotes marriage and blesses the newborn in his work as an imam at a mosque in the neighborhood of Bay Ridge.

IX. Love

P. 88 "Three Marines, among thousands of members of the United States Navy, Marine Corps and Coast Guard visiting the city, stopped in Times Square to chat with an entertainer known as the Naked Cowgirl."
The New York Times, May 21, 2009

P. 89 "BACK FROM IRAQ, INTO WELCOMING ARMS: American soldiers were welcomed home from duty in Iraq on Thursday during a ceremony in Fort Carson, Colo."
The New York Times, November 11, 2011
> ORIGINAL: FORT CARSON, CO—NOVEMBER 10: Family members and U.S. soldiers embrace following a welcome home ceremony for troops returning from Iraq on November 10, 2011 in Fort Carson, Colorado. More than 100 soldiers from the 549th Quartermaster Company, 43rd Sustainment Brigade returned after a seven-month deployment. They played a key role in removing excess equipment from Iraq as other troops withdrew from the region.

P. 90 "Settlers Clash With Israeli Forces in Hebron: Israeli soldiers and police officers forced Jewish settlers from a contested building in the West Bank city of Hebron on Thursday. Some settlers then went on an angry rampage, and Israel declared the southern West Bank off limits to nonresidents."
The New York Times, December 5, 2008
> ORIGINAL: In this Dec. 4, 2008 file photo, an Israeli police officer drags two Jewish settlers during the evacuation of a disputed house in the West Bank city of Hebron.

P. 91 "GRIEVING FOR CHILDREN: Brian Pacholski, a military policeman, comforted a friend, David Borello, who broke down yesterday after seeing three Iraqi children wounded while playing with explosives near Baghdad. As American forces fan out north and west of the capital, they face new violence."
The New York Times, June 14, 2003
> ORIGINAL: U.S. military police officer Brian Pacholski comforts his hometown friend, U.S. military police David Borello, both from Toledo, Ohio, at the entrance of the military base in Balad, about 50 kilometers (30 miles) northwest of Baghdad, Friday, June 13, 2003. Borello broke down after seeing three Iraqi children who were injured while playing with explosive material. Iraqi attackers hiding in a thicket of reeds rushed a U.S. tank column Friday night a few hundred yards from the entrance of the base.

P. 92 "Brittany Jacobs, with her son, at her husband's grave at Arlington National Cemetery, where President Obama spoke."
The New York Times, May 28, 2013
> ORIGINAL: On Memorial Day, Brittany Jacobs of Hertford, North Carolina sits with her son, Christian, at the gravesite of her husband, Marine Sgt. Christopher Jacobs, in National Cemetery in Arlington Virginia, USA on 27 May, 2013.

X. Death

P. 96 "AMBUSH: An Iraqi soldier was killed yesterday by marines who were ambushed in central Iraq."
The New York Times, March 27, 2003
> ORIGINAL: A U.S. marine walked past a dead Iraqi soldier killed in a firefight with U.S. marines early this morning after Iraqi troops laid an ambush for the marines as they headed north to Baghdad from a trench position in central Iraq north of the city of Nasiriya.

P. 97 "On the road to Baghdad, an American convoy passes an Iraqi killed in a fight with marines in March 2003."
The New York Times, March 19, 2008
> ORIGINAL: U.S. marine vehicles drove past a dead Iraqi soldier killed in a firefight with U.S. marines early this morning after Iraqi troops laid an ambush for the marines as they headed north to Baghdad from a trench position in central Iraq north of the city of Nasiriya.

Photography Credits

I. Nature

P. 14 Ozier Muhammad/*The New York Times*/Redux
P. 15 Moises Saman/*The New York Times*/Redux
P. 16 Jason P. Howe
P. 17 Baz Ratner/Reuters
P. 18 Tyler Hicks/*The New York Times*/Redux
P. 19 Damon Winter/*The New York Times*/Redux

II. Playground

P. 22 Omar Obeidi/Reuters
P. 23 Christoph Bangert/*The New York Times*/Redux
P. 24 Chris Ison/Press Association
P. 25 Jim MacMillan/Associated Press
P. 26 Doug Mills/*The New York Times*/Redux
P. 27 Max Becherer/Polaris

III. Father

P. 30 Susan Stava/*The New York Times*/Redux
P. 31 Damir Sagolj/Reuters
P. 32 Kahlid Mohammed/Associated Press
P. 33 J. Scott Applewhite/Associated Press

IV. God

P. 36 Flash 90/Reuters/Corbis
P. 37 John Moore/Associated Press
P. 38 Ashley Gilbertson/VII
P. 39 Staff Sgt. Lorie Jewell/U.S. Army via Getty Images

V. Pietà

P. 42 Ashley Gilbertson/VII
P. 43 Mohammed Salem/Reuters
P. 44 Gleb Garanich/Reuters
P. 45 Michael Kamber/*The New York Times*/Redux
P. 46 Joao Silva/*The New York Times*/Redux

VI. Painting

P. 50 Menahem Kahana/Agence France-Presse-Getty Images
P. 51 Ashley Gilbertson/VII
P. 52 Christoph Bangert/*The New York Times*/Redux
P. 53 Tyler Hicks/*The New York Times*/Redux
P. 54 Eros Hoagland/*The New York Times*/Redux
P. 55 Chang W. Lee/*The New York Times*/Redux
P. 56 Ruth Fremson/*The New York Times*/Redux
P. 57 Rina Castelnuovo/*The New York Times*/Redux
P. 58 Via Conflict Armament Research
P. 59 Rodrigo Abd/Associated Press

VII. Movie

P. 62 Stephen Crowley/*The New York Times*/Redux
P. 63 Tyler Hicks/*The New York Times*/Redux
P. 64 Andrea Bruce for *The New York Times*/Redux
P. 65 Javier Manzano/Agence France-Presse-Getty Images
P. 66 Abbas Momani/Agence France-Presse-Getty Images
P. 67 Wally Santana/Associated Press
P. 68 Takanori Sekine/Kyodo News
P. 69 Tyler Hicks/*The New York Times*/Redux
P. 70 Marko Drobnjakovic/Associated Press
P. 71 Anja Niedringhaus/Associated Press
P. 72 Damon Winter/*The New York Times*/Redux
P. 73 Mohammed Abed/Agence France-Presse-Getty Images

VIII. Beauty

P. 76 Natalie Behring
P. 77 Zohra Bensemra/Reuters
P. 78 Christoph Bangert/*The New York Times*/Redux
P. 79 NO CREDIT
P. 80 Wathiq Khuzaie/Getty Images
P. 81 Joao Silva/*The New York Times*/Redux
P. 82 Yonathan Weitzman/Reuters
P. 83 Rina Castelnuovo/*The New York Times*/Redux
P. 84 Tyler Hicks/*The New York Times*/Redux
P. 85 James Estrin/*The New York Times*/Redux

IX. Love

P. 88 Béatrice de Gréa/*The New York Times*/Redux
P. 89 John Moore/Getty Images
P. 90 Sebastian Scheiner/Associated Press
P. 91 Victor R. Calvano/Associated Press
P. 92 Pete Marovich

X. Death

P. 96 James Hill/Contact Press Images
P. 97 James Hill/Contact Press Images

Acknowledgments

My profound gratitude and indebtedness to Danielle VonLehe, Cindy Yetman, Tom Collicott, Yuko Uchikawa, Meg Handler, Arne Christensen, James Nugent, and Maurice Willaredt, without whose indefatigable research and technical wizardry this book would have been not only impossible but inconceivable. Special thanks to Daniel Power for his dedication, passion, and nerve.

David Shields is the internationally bestselling author of eighteen previous books, including *Reality Hunger* (named one of the best books of 2010 by more than thirty publications), *The Thing About Life Is That One Day You'll Be Dead* (*New York Times* bestseller), and *Black Planet* (finalist for the National Book Critics Circle Award). Forthcoming are *Flip-Side* (powerHouse, 2016) and *Other People* (Knopf, 2017). The recipient of Guggenheim and NEA fellowships, Shields has published essays and stories in *The New York Times Magazine*, *Harper's*, *Esquire*, *Yale Review*, *Village Voice*, *Salon*, *Slate*, *McSweeney's*, and *Believer*. His work has been translated into twenty languages.